Dreaming Bhutan

Journey in the Land of the Thunder Dragon

By Nicole Grace

for Laura

Dreaming Bhutan
Journey in the Land of the Thunder Dragon
Published by Mani Press
369 Montezuma Avenue, Suite 415
Santa Fe, NM 87501

Book cover design by Lisa Delorme Meiler
Book layout by Rachelle Painchaud-Nash
Bhutan Map and Flag images courtesy of Bhutan-360
All photographs by Nicole Grace

ISBN: 978-0-9747852-5-7
Library of Congress Control Number: 2011927180

WINNER
2011 International Book Awards, Travel: Pictorial *and* Travel: Recreational
2011 Paris Book Festival, Photography/Art

MANI PRESS
SANTA FE

Table of Contents

BHUTAN

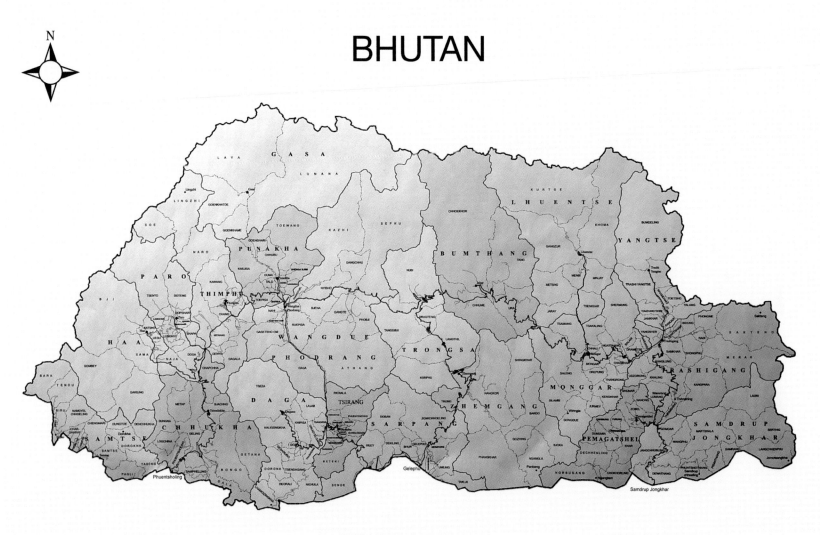

BHUTAN 360 | bhutan-360.com

Ode to Bhutan

Dream yourself into a magical world
Veiled in the clouds misting low across lush valleys
Enchanted Kingdom
Outside of Time…
Wrathful deities mash their teeth and growl
From painted stone walls
While red-robed monks chant in an ancient tongue
Prayers of devotion
Exploding from these snow-draped mountains
Like millions of multi-colored flags rising into the wide sky
Children leap and dance, singing the lineage songs
Robes and bright dresses flying, canoe-shaped shoes lifting up
To a chorus of holy creatures barking and cawing their delight
Dear Bhutan
Precious Gem
Hidden in the belly of God's
Great green-hilled Dragon,
Thundering his euphoric love
For his Home.

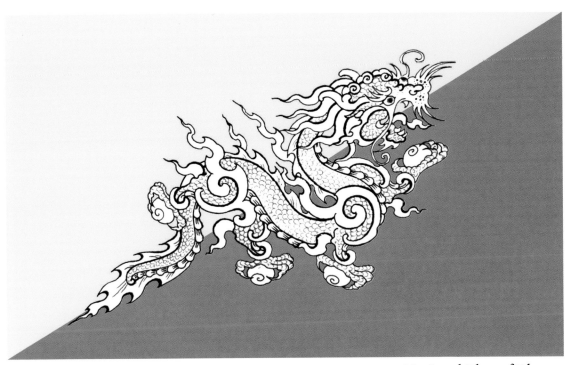

National Flag of Bhutan

Foreword

Nicole Grace's book, *Dreaming Bhutan*, is a beautiful book, conveying the great pristine beauty, peace and serenity of our sacred Buddhist kingdom.

It is a book that we cherish, and we thank her.

Her Majesty Ashi Kesang Choeden Wangchuck
The Royal Grandmother
Dechencholing Palace, Thimphu, Bhutan
June 2010

Introduction

Kuzuzangpo-la!
(*Greetings!* in Dzongkha, the official language of Bhutan)

Bhutan is truly a place outside of Time. Moments before your plane begins its descent towards Paro, an extraordinary sight meets your eyes. Off to your left, peeking out above a skywide carpet of fluffy white clouds, are the snow-covered Himalayas. The vision of these immense peaks floating in the upper atmosphere will take your breath away. It is perhaps the only appropriate way to prepare visitors for their imminent journey into the magical Land of the Thunder Dragon (*Druk Yul*).

Bhutan's unusual characteristics make one think of a cross between the mythical lands of Shangri-La and Brigadoon. It is a world of enchantment, ancient rituals and dress that seems not to have changed in hundreds of years.

As you turn these pages, you can explore some fascinating places, and have a small window into the endless treasures of this supernaturally beautiful country.

Since there are many sources available in print and on the Internet for learning facts and figures about Bhutan, her culture and people, I have chosen not to repeat that information here. This book is not intended to be, nor is it, a detailed guide or reference book for travel or study. Like waking from a rare, exquisite dream, and finding yourself reliving its charms in vivid flashes, I have attempted to capture a few precious moments.

While these images and quotes will give you a brief glimpse of Bhutan's wonders, no photograph, or even hundreds of them, can ever do justice to the experience of visiting this land yourself. May you have the privilege.

My guides on this journey could not have been more generous with their time and knowledge of Bhutan's culture, history and land. In addition, Scott Wilson has contributed his peerless editing skills to this manuscript. I am very grateful to him for his wisdom and perspective.

Any errors of fact or language within these pages are entirely my own.

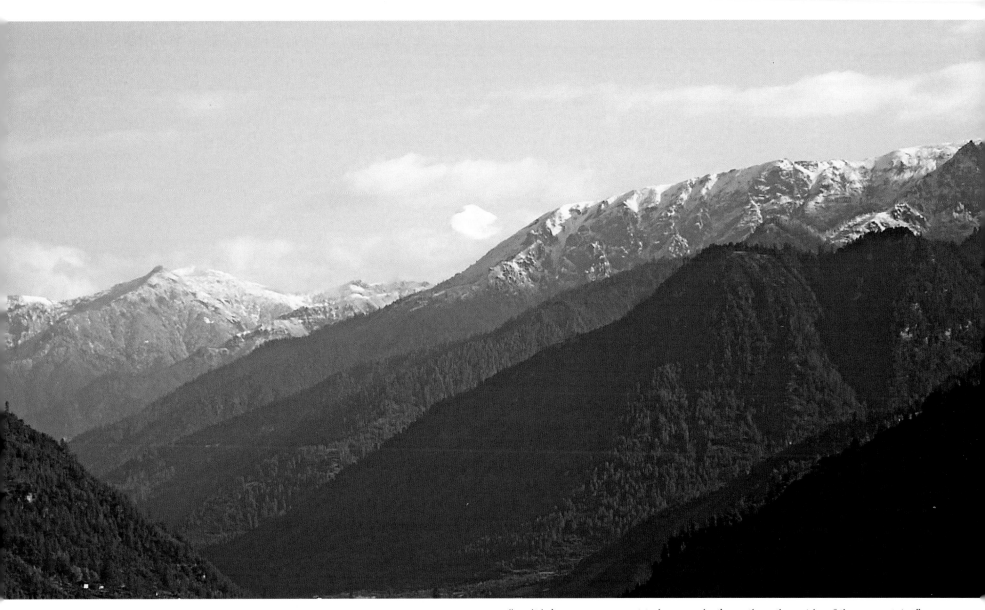

"…didn't you ever want to know what's on the other side of the mountain?"
– Lost Horizon[1]

Paro Valley, Paro

The Paro valley, enshrouded by a veil of cloud after a morning downpour, provides the perfect scenery for a visitor's first steps into this mystical land.

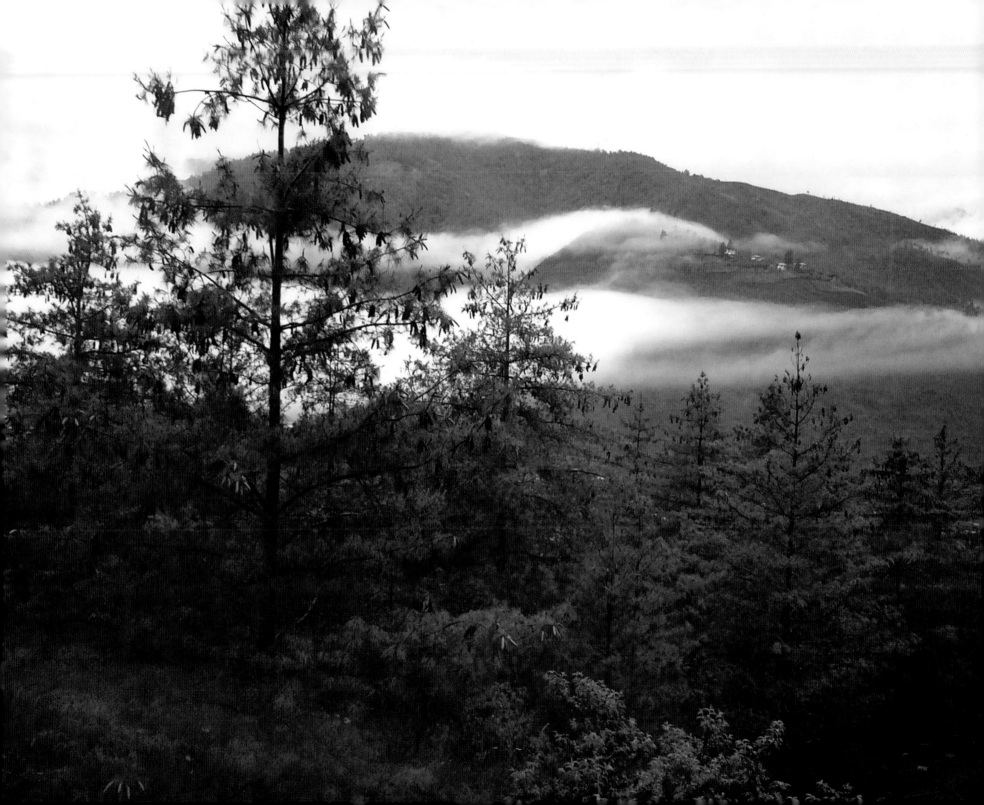

Taktsang Goemba (Tiger's Nest Monastery), Paro

The legend of this remarkable place is that the great *mahasiddha*, Guru Rinpoche, flew to the high cliff where the monastery is now situated, on the back of a tigress and meditated in a cave there for many months.

It is believed that making the arduous trek up to Taktsang burns away negative karmas.

The temples were devastated by fire in 1998, but have since been beautifully restored.

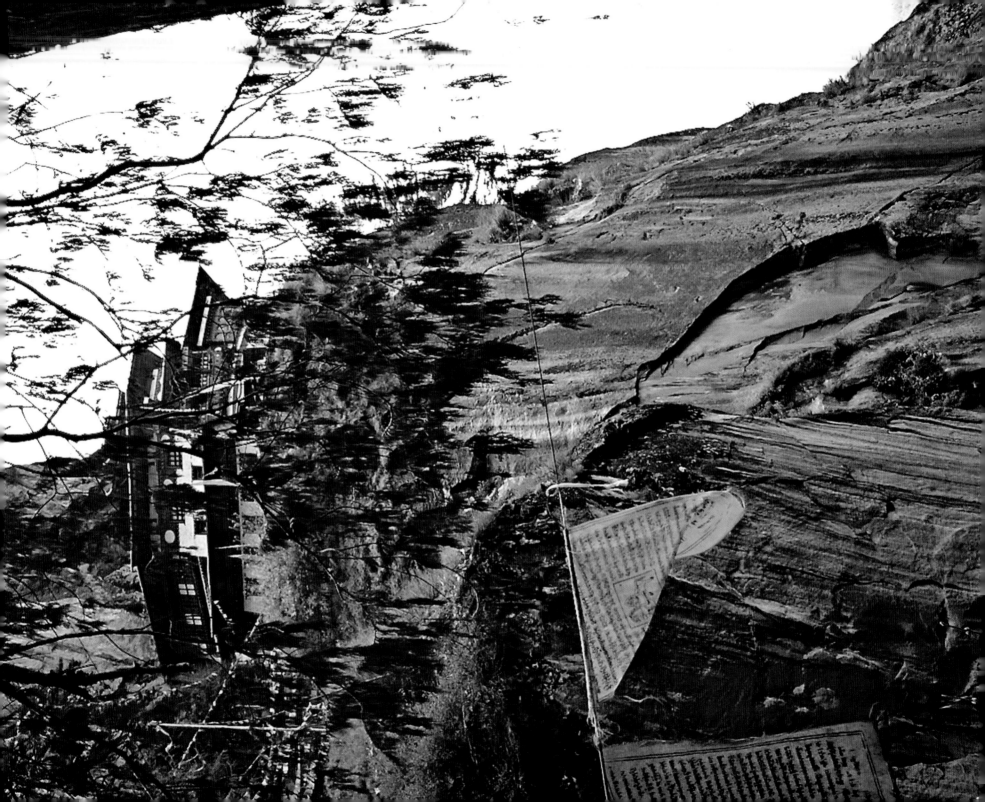

Taktsang Goemba Close View

Practicing Buddhists – or any visitors comfortable with this etiquette – who enter into Bhutanese temples, are encouraged to make three prostrations towards the seat of the chief abbot/teacher (if there is one), followed by three prostrations towards the center altar. You may then make a suitable offering at the altar. The attending monk may then offer to pour oil or water that has been blessed into the palm of your hand. You take a ceremonial sip from your palm and then touch the oil to the crown of your head to receive the blessing.

The Buddha said that when we dedicate merit, it is like adding a drop of water to the ocean. Just as a drop of water added to the ocean will not dry up but will exist as long as the ocean itself exists, so, too, if we dedicate the merit of any virtuous deed, it merges with the vast ocean of merit that endures until enlightenment.

– Padmasambhava (Guru Rinpoche)

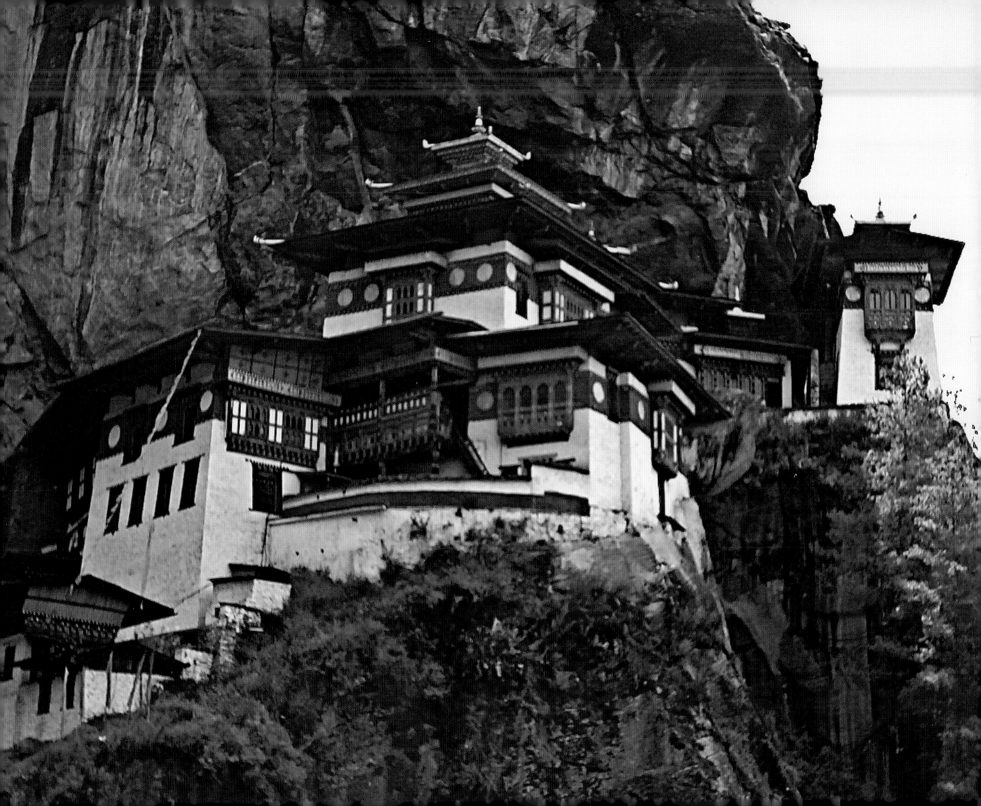

Yeshe Tsogyal's Retreat, Paro

This small shrine, wedged high above the ground between sheer cliff walls, is visible from the path to Taktsang Goemba. It is where Yeshe Tsogyal, Padmasambhava's spiritual consort, meditated and practiced.

It is fascinating to note the structural differences between the locations where these great beings meditated. Guru Rinpoche sat at the top of a high peak, on a tiny plateau jutting from the rock. Yeshe Tsogyal practiced in a womb-like cavern created by the meeting of two immense stone faces.

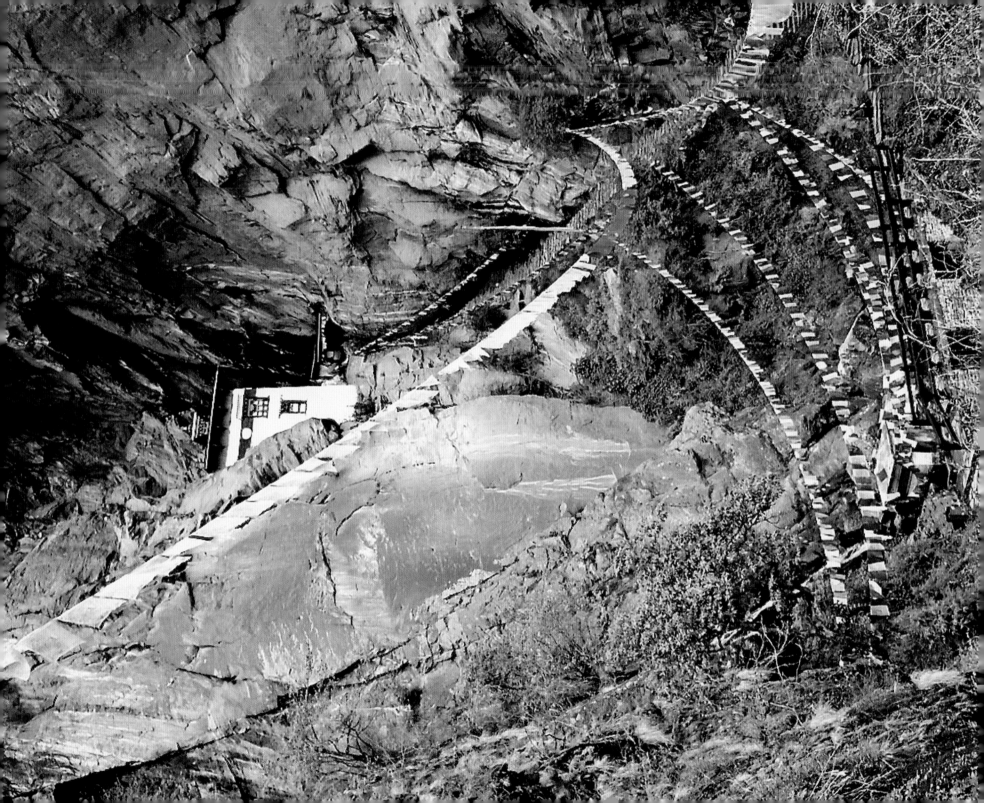

Footsteps of Guru Rinpoche, Paro

This pyramid-shaped boulder is found along the pathway to Taktsang Goemba. If you look closely, you can see two long footprints embedded in the rock that are said to belong to Padmasambhava.

There are several very holy places in Bhutan where you can see footprints, and even a full body-print (Kurjey), made by the spiritual power of Padmasambhava *(see page 94).*

You may notice that the only photographs of holy places found in this book were taken outside. With few exceptions it is prohibited to take photographs of the inside of temples anywhere in Bhutan, including some temple grounds. These sacred places may only be viewed in person.

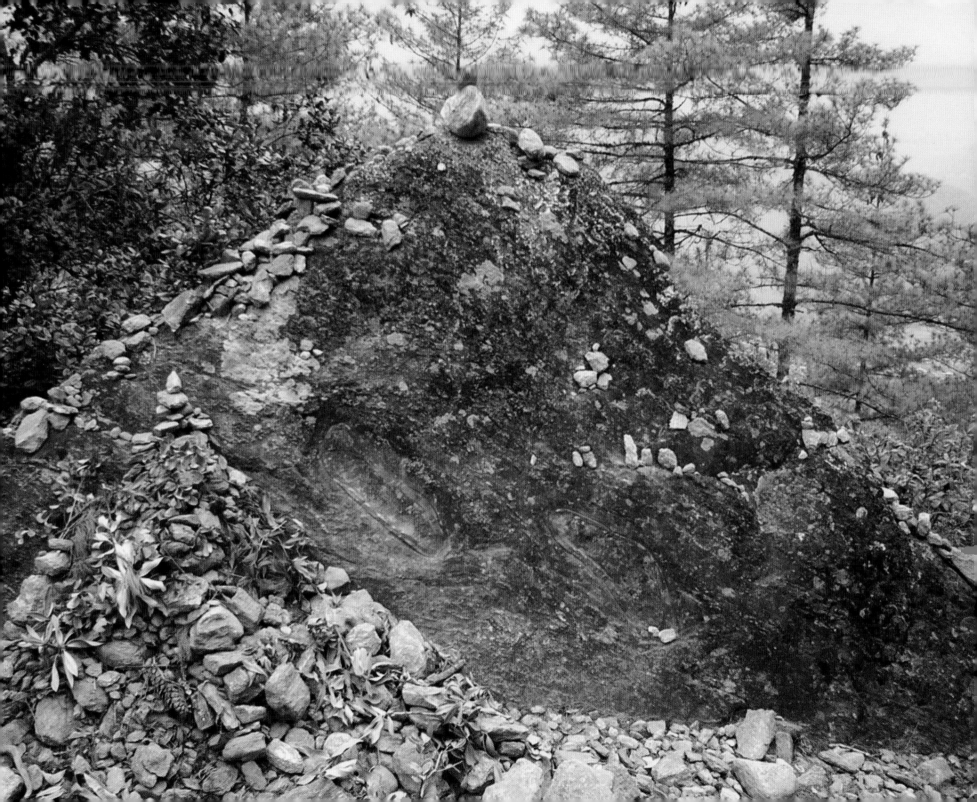

Highest Point in Paro

Located more than 2250 meters above sea level (approximately 7382 feet), this marker is reached by a narrow, winding country road.

Sit in the world, sit in the dark.
Sit in meditation, sit in light.
Choose your seat.
Let wisdom grow.

– Buddha[2]

ཨོཾ་ཨ་ཀ་ར་ས་ཤ་ང་བ་ ཞེ་ས་ཨ་བ་ར་ཤ་ང་ཤ་ཤ་བ་ ||

"The greatest religion never gives suffering to anybody"

LORD BUDHA

I-DEC Haa Dzongkhag

Prayer Flags, Paro

You will often see tall, vertical flags like the ones here, posted in the ground in large groupings. These are located near the high point marker on the previous page.

With the colors and movement of these flags, you can almost imagine hundreds of schoolchildren, swaying side to side and singing hymns.

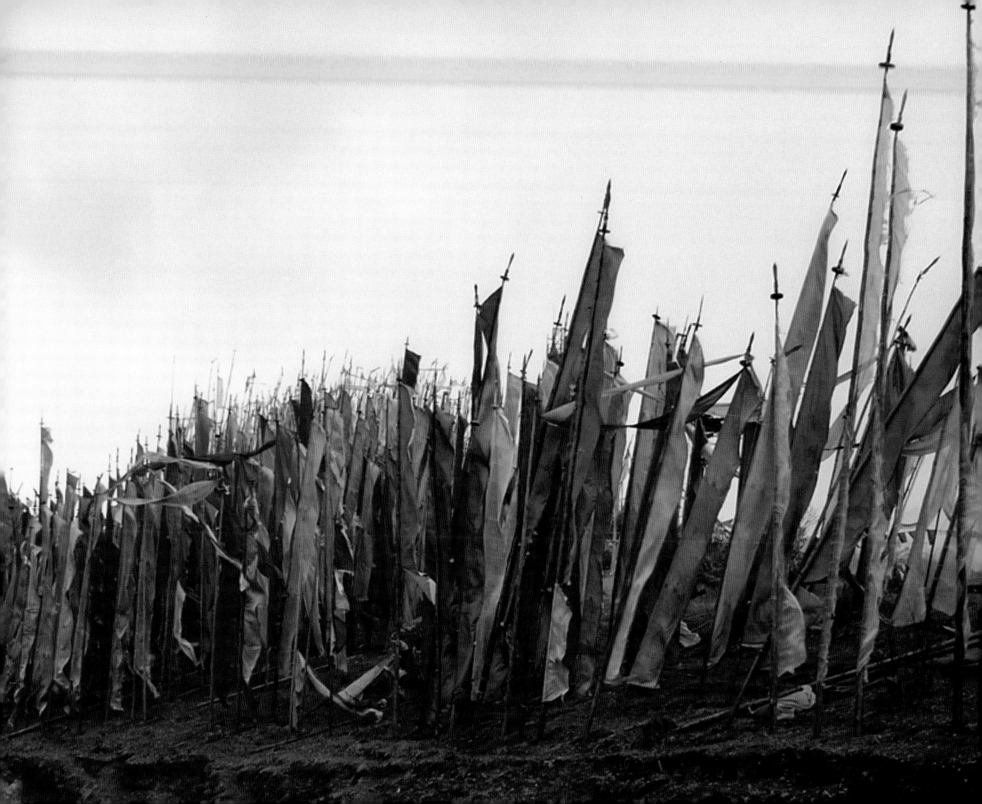

Changangkha Lhakhang, Thimphu

Changangkha Lhakhang is the oldest temple in Thimphu, built in the 12th century. Visitors circumambulate the main building three times before entering. As you pass the outer walls covered with these prayer wheels, it is believed to bring good karma if you turn each one, releasing its prayers into the wind.

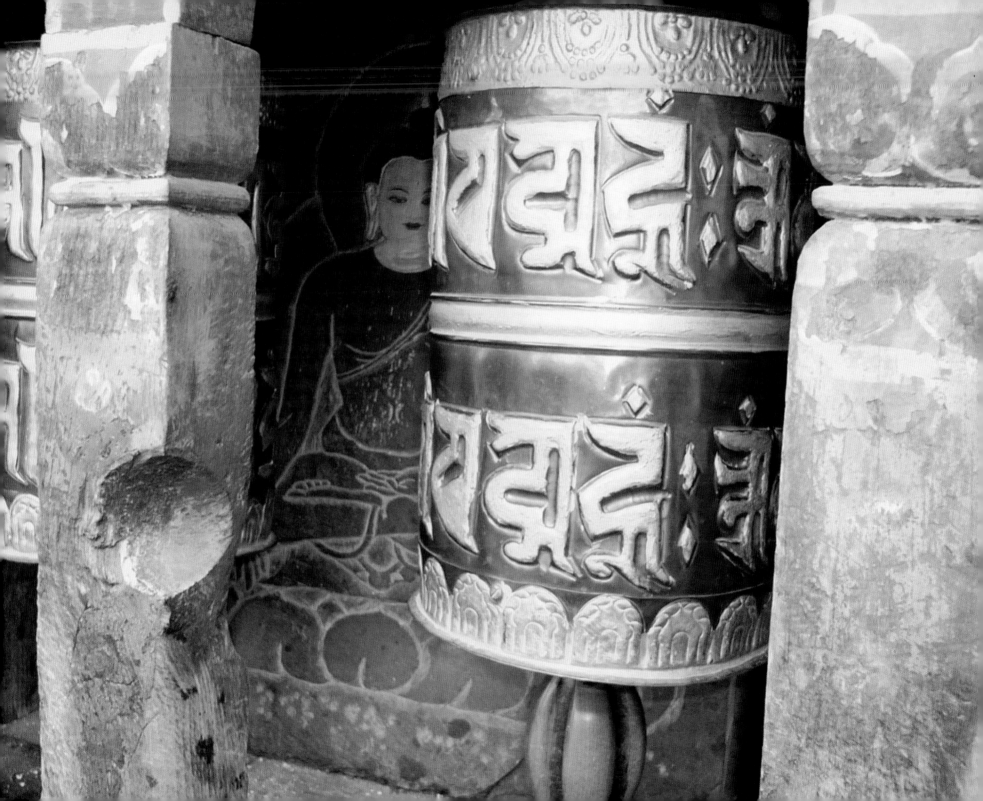

Traditional Dance Exhibition, Thimphu

National Institute for Zorig Chusum, school of 13 traditional arts and crafts.

Students of this institution learn to perfect crafts such as *thangka* painting, sculpting, weaving and sewing of traditional garments. The skill of these young people is truly amazing.

A dance exhibition, with students leaping and turning, singing and banging drums in their brightly colored silk costumes, is a visual feast.

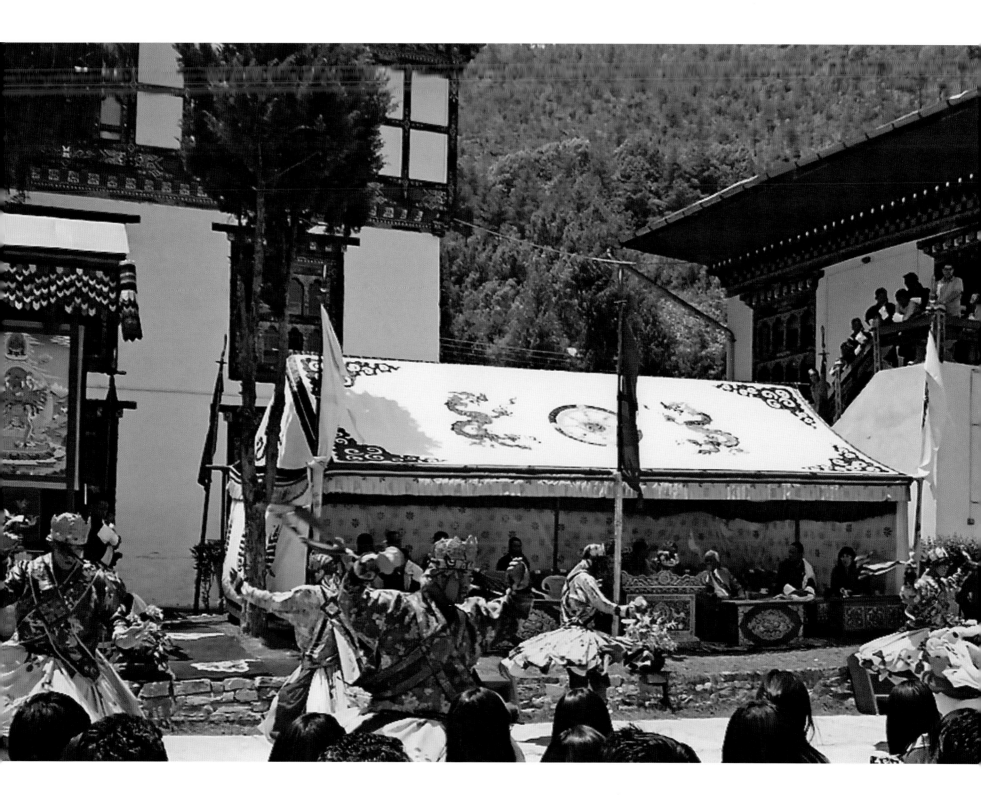

Thangka Grid

This is a Zorig Chusum student's demonstration of the "grid" system of painting *thangkas*. This sacred art form, when authentic, is practiced according to mathematical levels of precision. All *thangkas* begin with a carefully measured and plotted drawing of the main form.

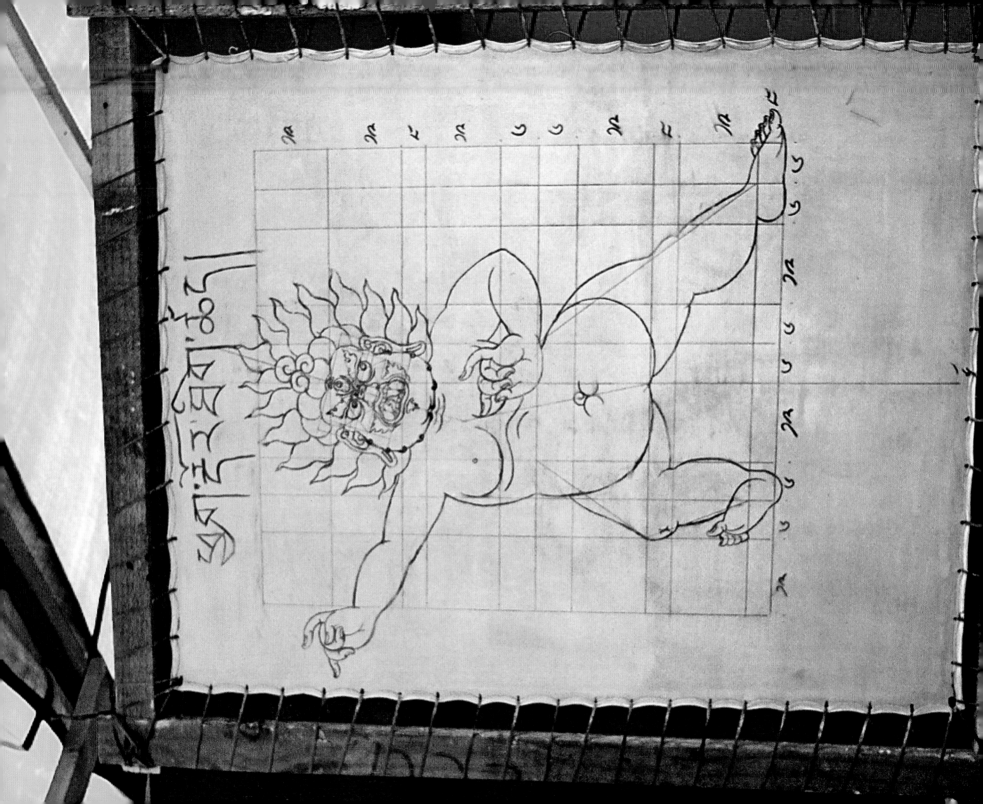

108 Chortens, Druk Wangyal Chorten, Dochu-La

As you journey from Thimphu to Punakha, you cross the Dochu-La Pass. This cluster of gilded *chortens* rises up on a small hill as you reach an altitude of over 10,000 feet.

The *chortens* were built in 2005 by Her Majesty Ashi Dorji Wangmo Wangchuck at an unusual time of conflict in Bhutan. Militants from India had crossed into southern Bhutan and were refusing to leave until they had won independence from India. Despite repeated attempts by His Majesty the (Fourth) King to resolve the issue through peaceful negotiations, the militants would not leave Bhutan. Under the King's leadership, Bhutan security forces began military action. With impressively low casualties, the troops were able to remove the militants in a few days.

The Queen installed this group of 108 *chortens* as a physical manifestation of Bhutan's prayers for the security and well being of everyone involved in the conflict.

Off to the side one can have an exquisite view of the Himalayas looking down on the valley below. Cloud wisps hang in horizontal drifts below the peaks, shrouding the landscape in a mystical concert of shadow and sunlight.

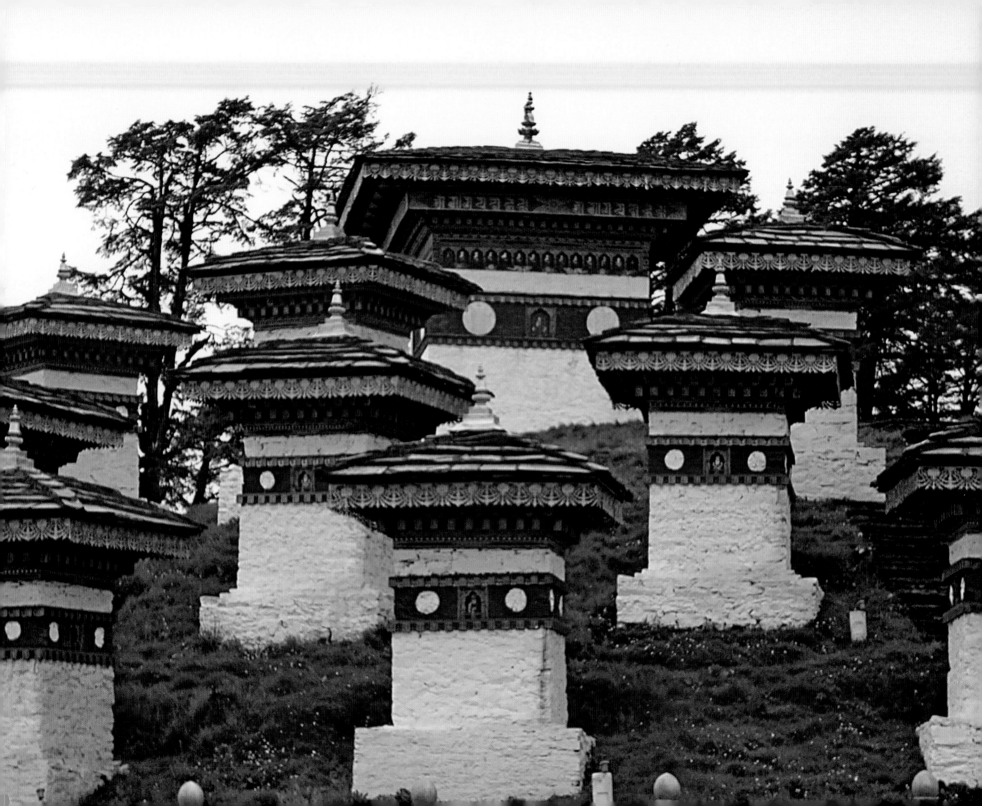

Traditional Cantilevered Bridge, Punakha Dzong, Punakha

The word *dzong* is translated as "monastery" or "fortress."

This recently reconstructed bridge, crossing the Mo Chhu ("Mo" river), connects Punakha village with the Dzong.

Few cross over the river.
Most are stranded on this side.
On the riverbank they run up and down.

But the wise man, following the way,
Crosses over, beyond the reach of death.

– Buddha[3]

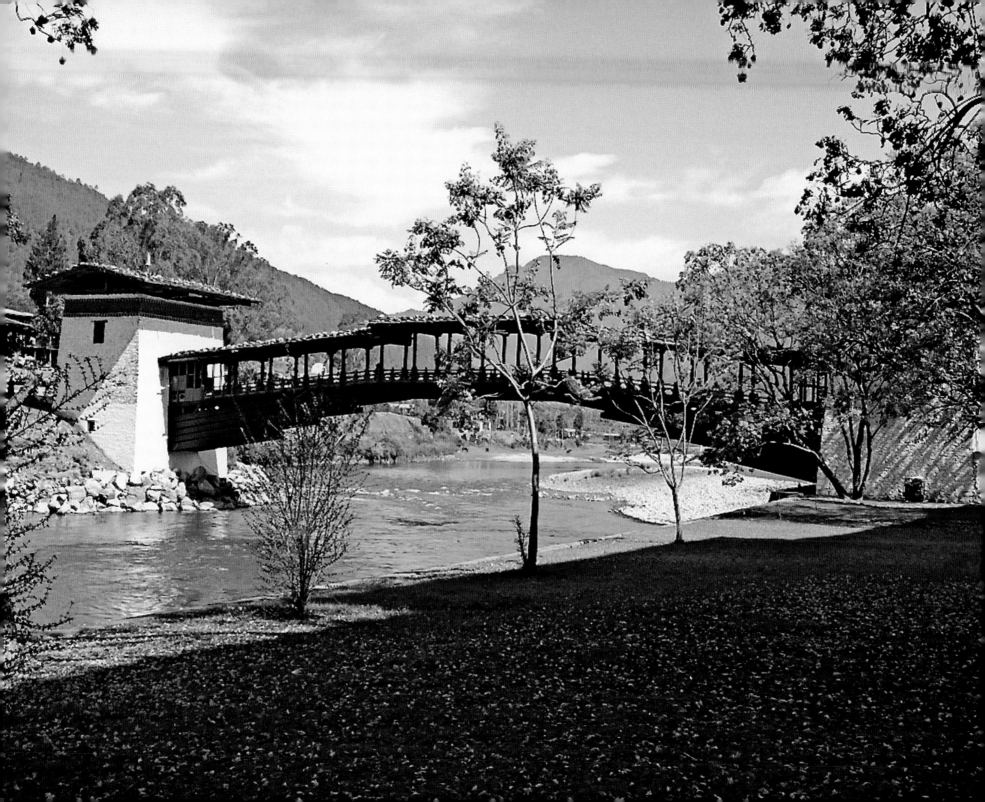

Punakha Dzong

This is the winter home of Bhutan's central monastic community and His Holiness the Je Khenpo, spiritual leader of Bhutan.

The Dzong is significantly situated at the confluence of two rivers: the Pho Chhu (male/father river) and Mo Chhu (female/mother river).

While the Punakha Dzong grounds are incredibly beautiful, they are made even more lovely by His Holiness the Je Khenpo's presence there. When he makes his annual move with the central monastic body from Punakha to Thimphu, their summer home, throngs of people mass along the sides of the road to get a glimpse of him passing slowly by and receive his blessing.

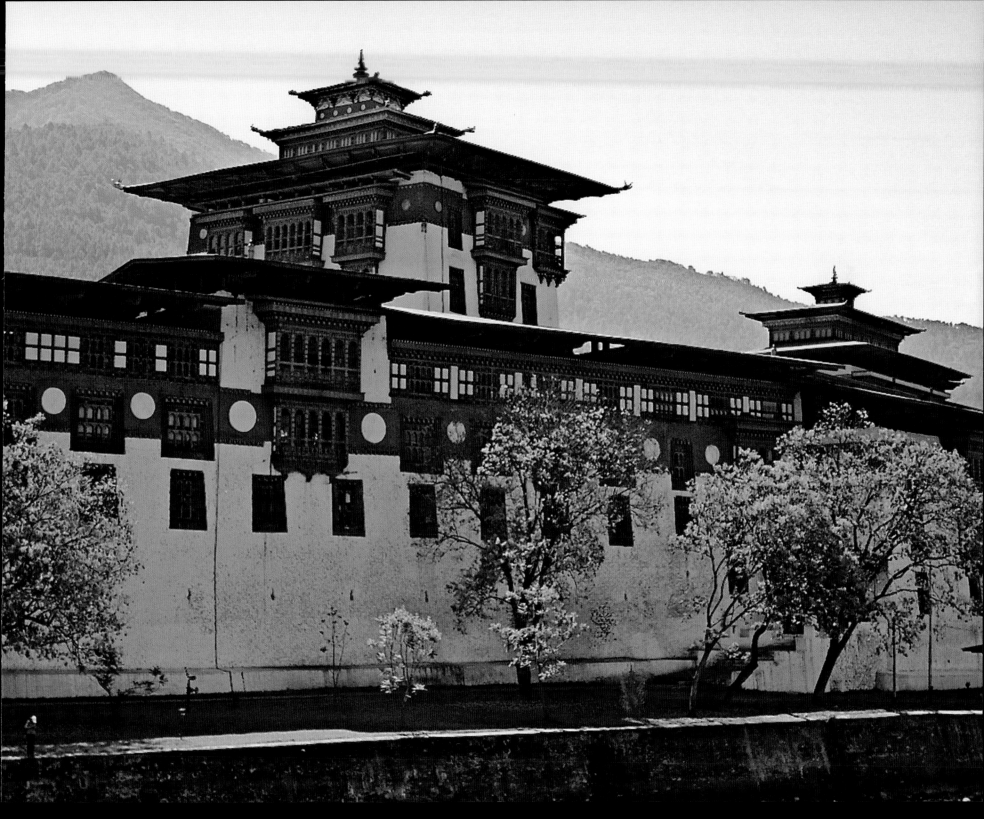

Yama Holding the Wheel of Life, Punakha Dzong

This spectacular artwork is painted on the wall outside the entrance to Kuenrey, an enormous and magnificent temple within the Punakha Dzong complex. Inside Kuenrey is a striking, 35 foot-high sculpture of Shakyamuni Buddha, made out of the five "precious substances" and medicinal clay.

This mind of yours is inseparable luminosity and emptiness in the form of a great mass of light, it has no birth or death, therefore it is the buddha of Immortal Light. To recognize this is all that is necessary. When you recognize this pure nature of your mind as the Buddha, looking into your own mind is resting in the Buddha-mind.

– The Tibetan Book of the Dead (Bardo Thödol)[4]

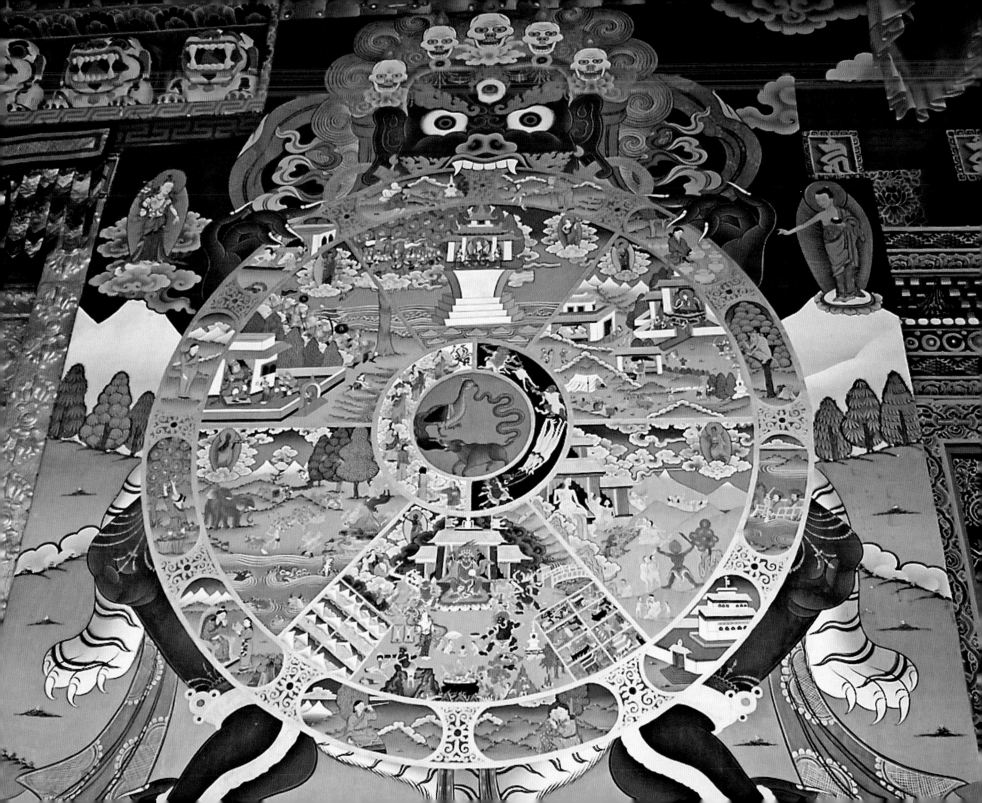

Machen Lhakhang, Punakha Dzong

This ornate temple houses the relics of the Tibetan lama and founder of Bhutan, Shabdrung Ngawang Namgyal (1594-1651), where he rests in an "eternal retreat."

He was responsible for developing the unique system of governance in Bhutan, where power is divided between administrative government (called *Deb Raja*) and spiritual authority (called *Dharma Raja*).

The building is so sacred that only three living people are allowed to enter: the former (Fourth) King, the current (Fifth) King and the Shabdrung's caretaker. The caretaker is responsible for bringing the Founder daily meals and maintaining the temple, as a sign of the country's reverence for the being who created their earthly home.

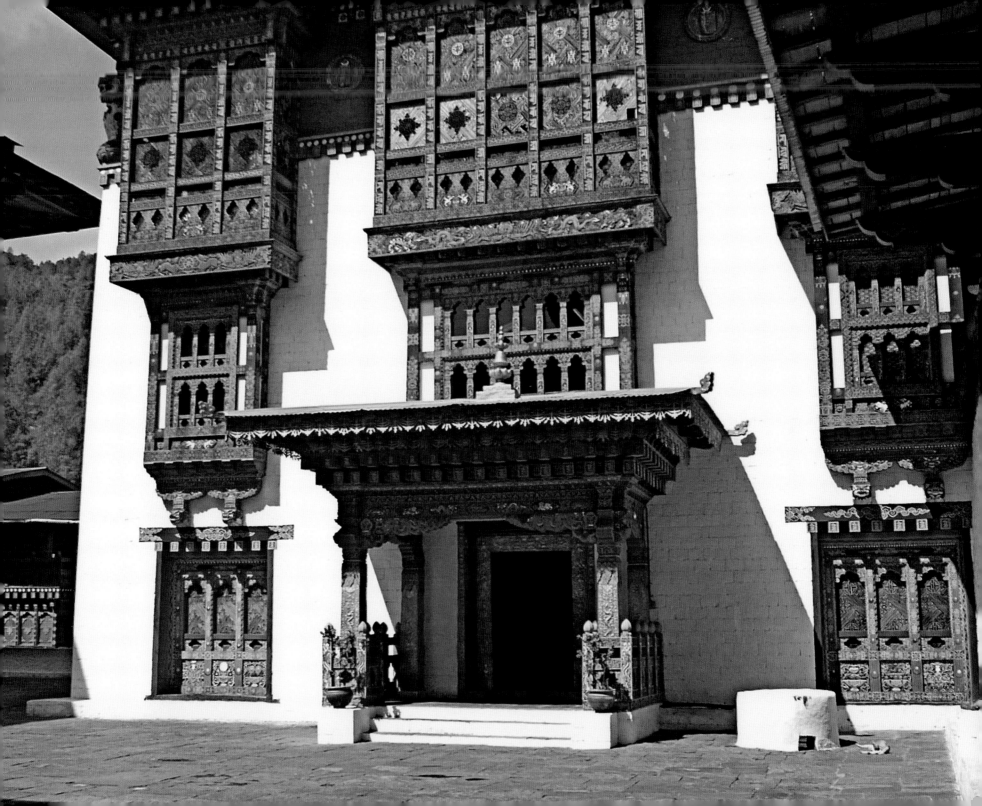

Temple Guard and Monk Outside Punakha Dzong

...you hold on to your identity as if it had some autonomous existence – as if it truly belonged to you. But if you examine it carefully, you will find that it has no intrinsic reality – as is the case with the name of anything. Take the word 'lion' for instance. It is made up of the letters, l, i, o, and n. Take those four letters apart, and there is nothing left; the name has vanished.

– Dilgo Khyentse Rinpoche[5]

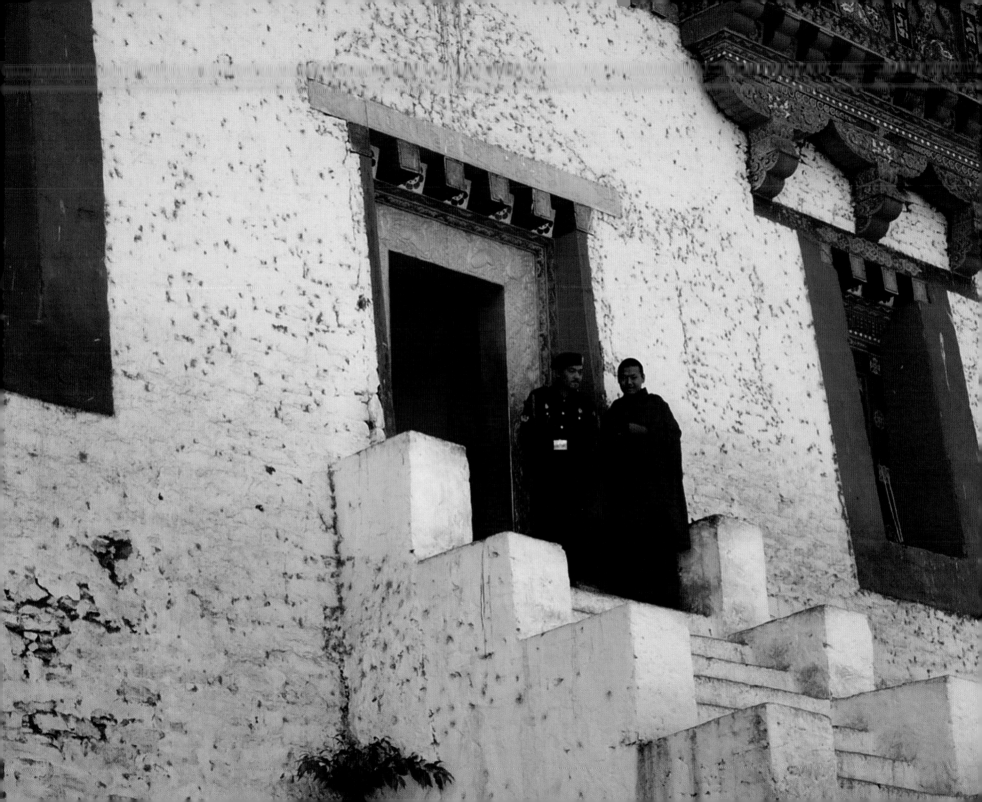

Chimi Lhakhang, Punakha

This is the temple of Drukpa Kunley, the "Divine Madman."

Perched at the top of a hill of cascading rice paddies, the temple seems to emanate the great spiritual power of Drukpa Kunley across Punakha. Inside, visitors may have the good fortune to encounter a very young monk in red robes, who might tap a bow — used by the Divine Madman himself — on the top of your head. The touch of that empowered object is not easily forgotten.

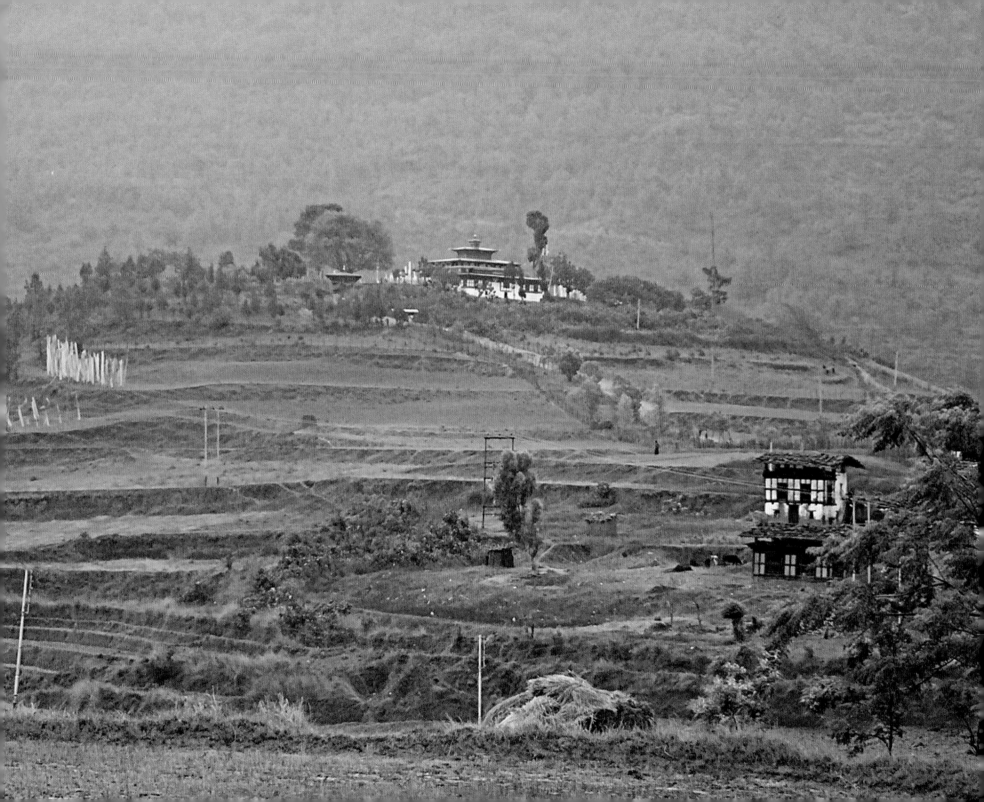

Chimi Lhakhang Grounds

Behind the temple, lush lavender-colored trees bloom amidst a small forest of vertical prayer flags, green hills and low-floating clouds.

One day he visited the monastery of Drepung. Sitting with the monks he thought he should play a joke on the Moral Guard.

"I would like to become a novice," he told them.

"Where do you come from?" he was asked.

"I am a Drukpa," he said.

"Do the Drukpas have good voices?"

"I don't have such a good voice," he told them innocently, "but I have a friend who is an excellent chanter."

"Bring your friend with you tomorrow," they told him.

The next day when the monks had assembled, the Lama brought a donkey by the ear, covered him with a red robe, and sat him down at the end of the line of monks.

"What is this!" exclaimed the Moral Guard in wrath.

"This is my friend with the good voice," Kunley told them, kicking the donkey to make it bray. The Guard chased him away with sticks, with the Lama shouting over his shoulder to them, "You people care more about chanting than meditation!"

– The Divine Madman[6]

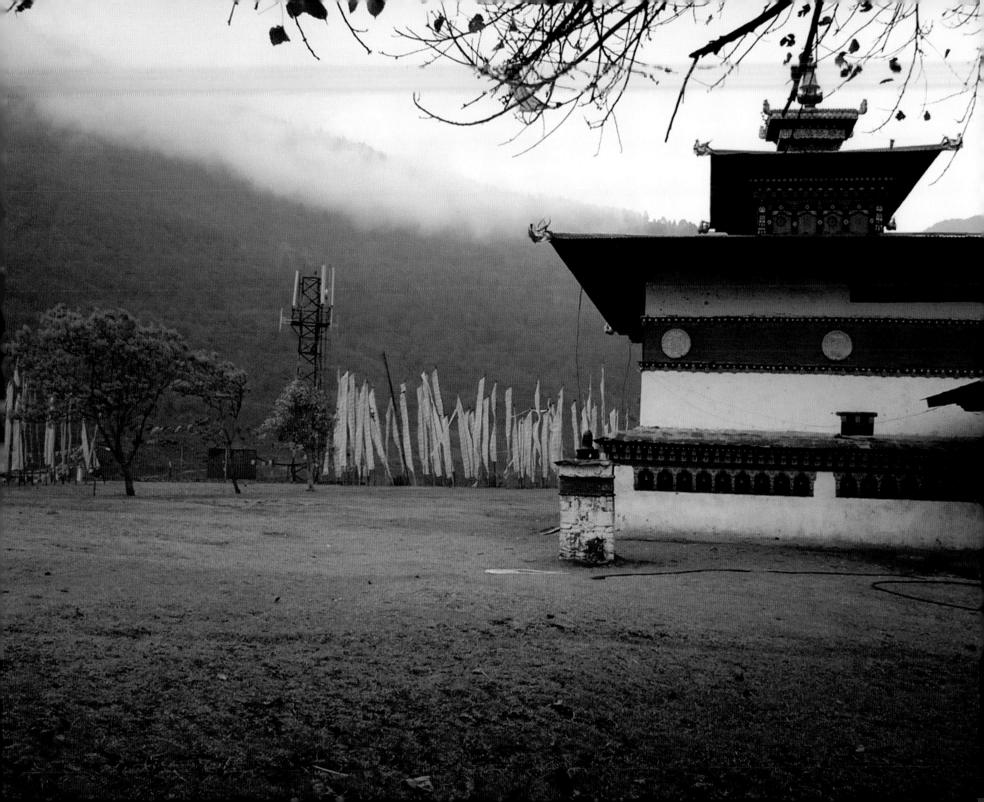

Fertility Symbols, Punakha

It is common to see these fertility symbols painted on buildings and homes across Bhutan. However, near the Drukpa Kunley temple, they seem to be everywhere. Westerners' reactions to these enormous, decorated penises range from amusement to fascination to astonishment. In fact, they are a familiar sight here and are believed to confer great blessings. The symbols are rooted in the history of the wandering bodhisattva, Drukpa Kunley, and his travels through the country, where he drank *chung* (a local beer) and "consecrated" the homes and bodies of many women with his "divine thunderbolt of wisdom."

Drukpa Kunley then decided to return to his homeland of Ralung. As he was ascending from Palnashol, he encountered an old man called Sumdar who was eighty years old. He was carrying a painted scroll, a Kahgyu Lineage Thangka, that had been well executed but lacked the final gold touch.

"Where are you going?" the Lama asked him.

"I am going to Ralung to ask Ngawong Chogyal to bless this scroll that I've painted," replied the old man.

"Show me your scroll!" said the Lama. The old man gave it to him, asking him his opinion of the work. "Not bad at all," the Lama told him, "but I can improve it like this." And he took out his penis and urinated over the painting.

The old man was shocked speechless, but finally he managed to say, "Apau! What have you done, you madman?" And he began to cry.

The Lama rolled up the wet scroll and calmly returned it to the old man. "Now take it for a blessing," he said.

When the old man reached Ralung he was granted audience by Ngawong Chogyal. "I painted this Kahgyu Lineage Thangka to gain merit," he told the abbot, "and I have brought it to you for your blessing. But on the way I met a madman who urinated on it and ruined it. Here it is. Please look at it."

Ngawong Chogyal opened it and saw that where the urine had splashed it was now shining with gold. "There's no need for my blessing," he told the old man, "It has already been blessed in the best possible way." The old man gained insurpassable faith and gave loud thanksgiving.

"My scroll has gained a blessing which makes it identical to Drukpa Kunley himself!" he cried, and went happily away. It is said that you can still see this painted scroll at the Dorden Tago Temple in Thimphu.

– The Divine Madman[7]

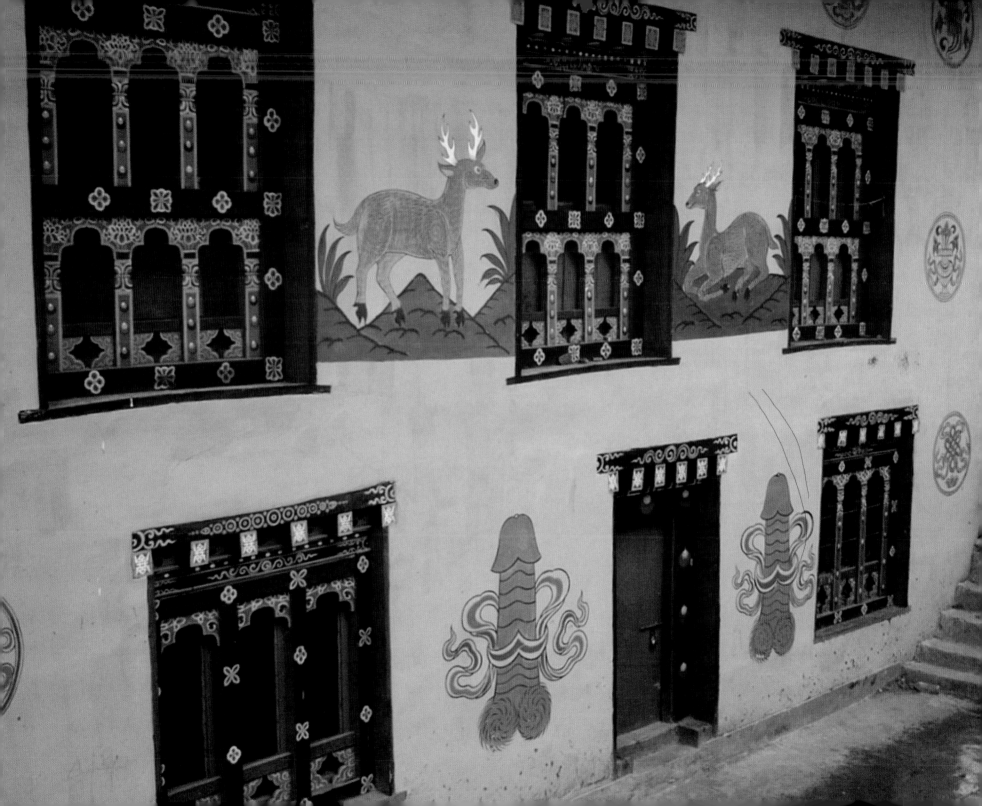

Trongsa Dzong, Trongsa

Dzongs are divided into two main areas: residences and practice areas for monks, and administrative government offices.

Trongsa Dzong offers some of the most splendid architecture in Bhutan. The complex is adorned with magnificent gardens and surrounded by colorful trees.

The fascinating story of the Dzong's founding begins with a man meditating in a tiny house overlooking the site of the future fortress. Every night he would see a butter lamp alight in the same place below his house. Finally, he hiked down towards the light and found a butter lamp mysteriously floating in a small lake. The Dzong was built on this site. The original lake remains there today in a protected area of the Dzong, behind a locked door.

An eagle nesting on a crag I never saw
To soar with elegance and ease until
His sixfold skill in flight was gained.
But with mighty beating wings, his art well learned,
He cuts across the razor-sharpness of the gale,
Alighting in whatever place he wills.

– Yeshe Tsogyal[8]

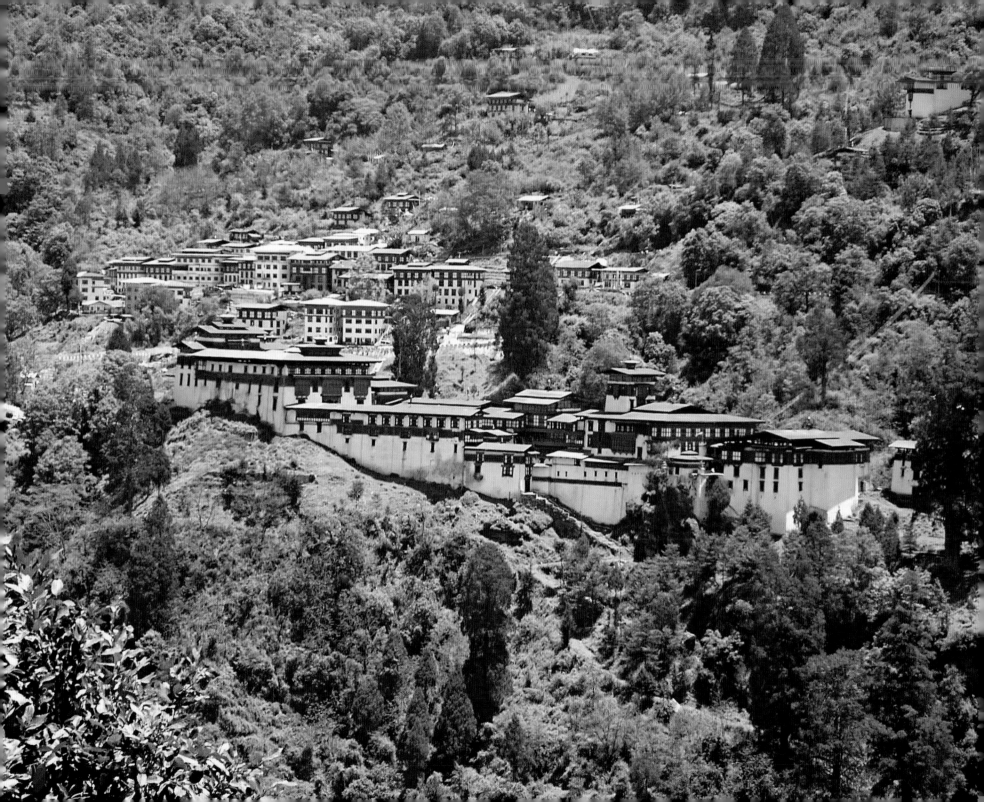

Trongsa Dzong Courtyard

This handsome and unexpected denizen of the Dzong was spotted having an afternoon snack inside the complex.

Bhutanese respect the presence of enlightenment in all sentient beings. Visitors will spot both wild and domesticated animals mingling with their human neighbors in all corners of the country. The constant soundtrack of barking dogs, birds calling and insects buzzing contributes a unique sonic color to your journey.

It is not uncommon to have your car brought to a complete halt in the middle of the road, blocked by a handful of passing yaks. You quickly discover that even the most vigorous horn honking has no visible influence upon their speed or direction, although locals never seem to give up hope that it will.

Inside Wall, Trongsa Dzong

These types of religious paintings can be seen both inside and outside of temples and even government office buildings.

This lovely artwork of a female deity is found on the wall of a simple hallway in the area of government offices inside the Trongsa Dzong complex.

The Bhutanese dedicate a humbling attention to aesthetics in nearly every aspect of their lives. Even simple, country farmhouses can look like great temples to the uninitiated visitor. In fact, architecture standards are government regulated to ensure Bhutan retains its unique, cultural charm.

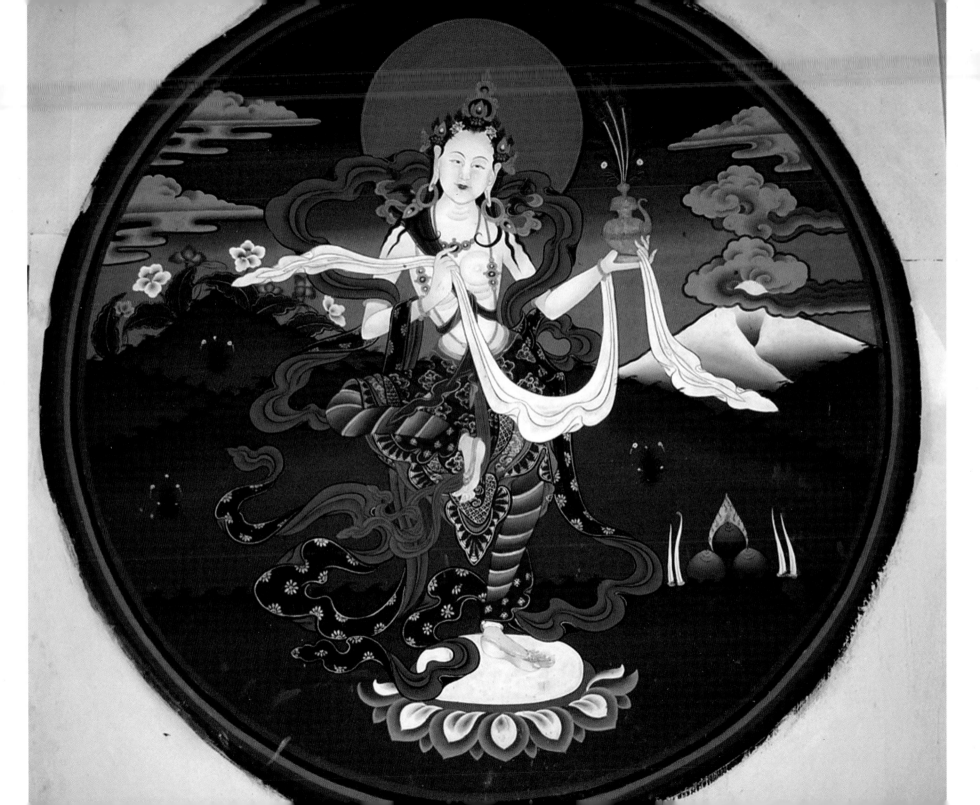

Chorten, Road to Bumthang

Chorten is the Bhutanese word for "stupa." These monuments are visual representations of the Buddha sitting in meditation. They symbolize enlightenment.

This *chorten* forms a pair with an exact copy located in Nepal.

> Follow the awakened
> And from among the blind
> The light of your wisdom
> Will shine out, purely.

> – Dhammapada: The Sayings of the Buddha[9]

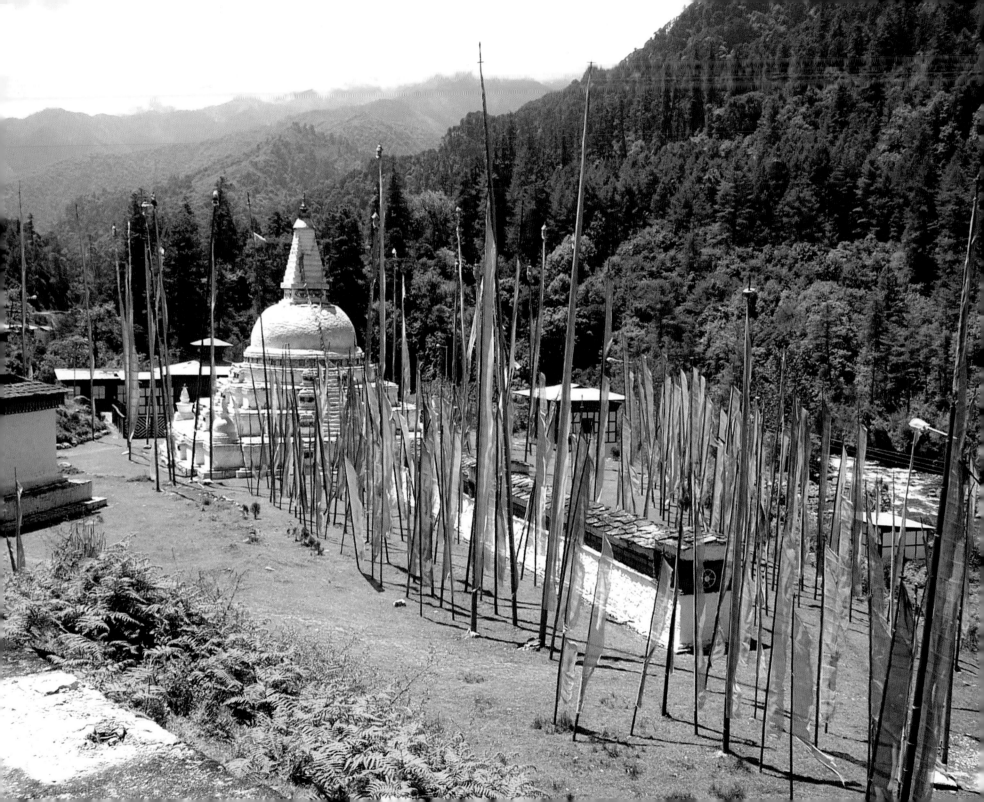

Himalayas, Road to Bumthang

This breathtaking view is visible along the winding road to Bumthang.

While he watched and pondered, a strange transformation took place. The light turned to bluish over the whole mountain, with the lower slopes darkening to violet. Something deeper than his usual aloofness rose in him – not quite excitement, still less fear, but a sharp intensity of expectation. He said: "You're quite right…this affair grows more and more remarkable."

– Lost Horizon[10]

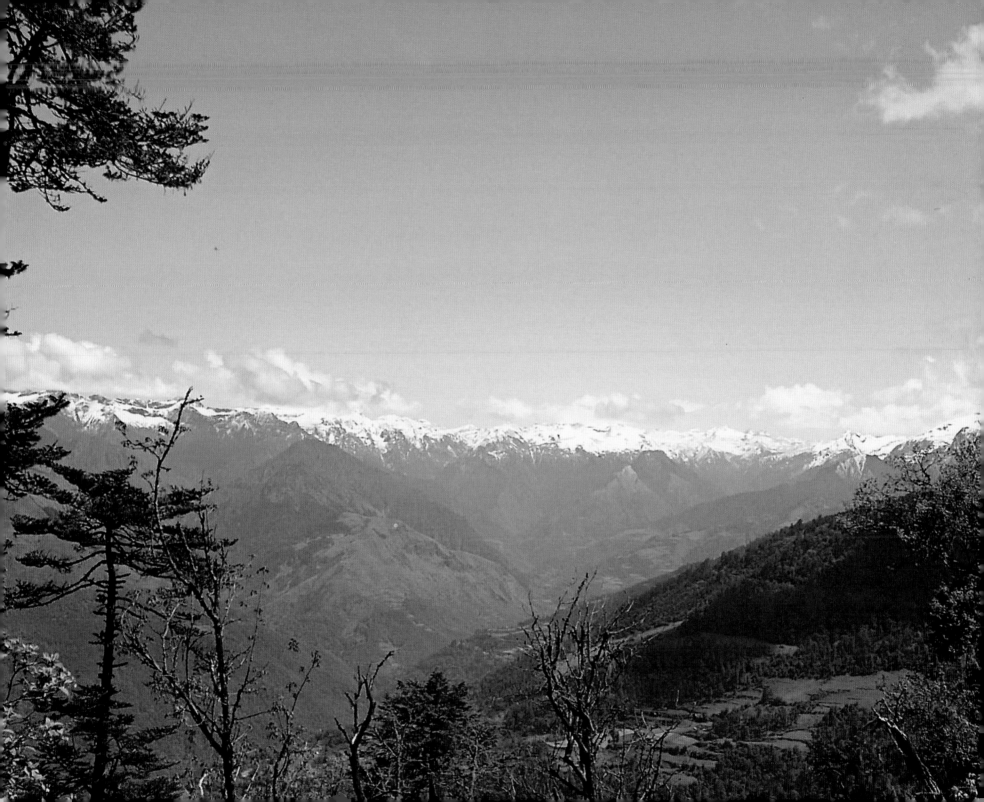

Guru Rinpoche Painting, Road to Bumthang

This remarkably faithful depiction of Padmasambhava looks like a perfectly weathered, preserved piece of history. In fact, it was painted on the side of a cliff wall during the filming of the 2003 movie, "Travelers and Magicians."

The film, directed by a Buddhist monk and *Rinpoche*, was made entirely in Bhutan, employing many locals for the cast.

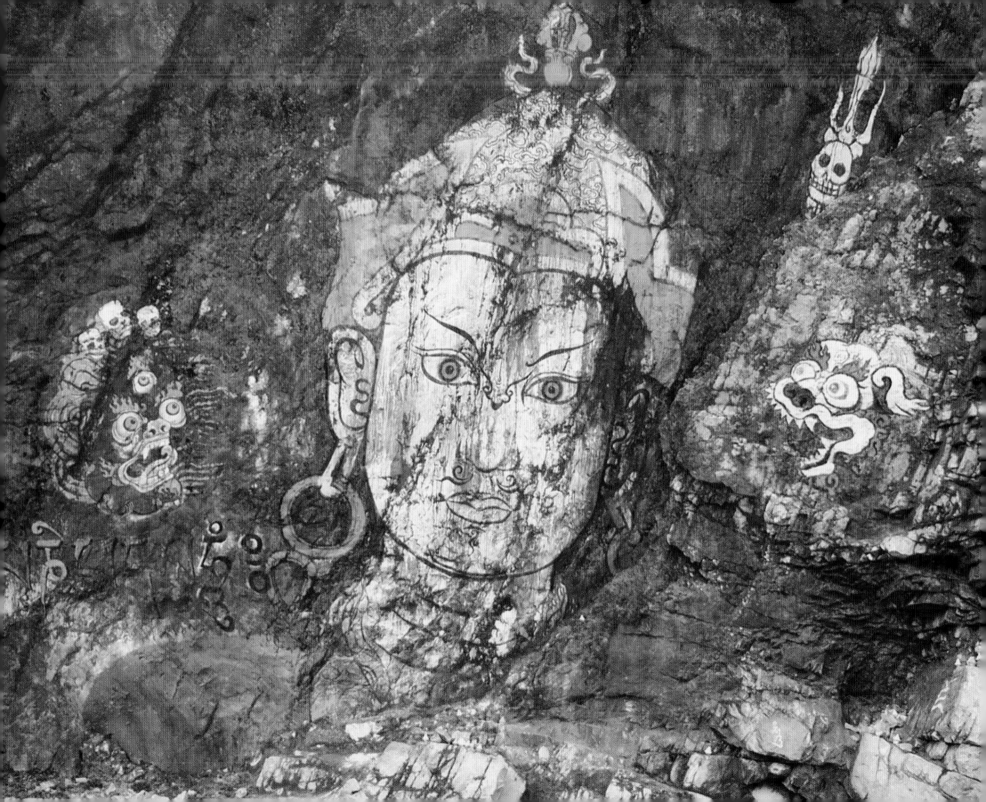

Buddhist Painting, Road to Bumthang

This artwork was also created for the filming of "Travelers and Magicians."

The text around the image of the *chorten* reads:

May all Sentient beings be free from
Wanting to be praised,
Not wanting to be criticized.
Wanting to be happy
Not wanting to be unhappy
Wanting to gain
Not wanting to lose,
Not wanting to be unknown
Thus prayed at (the) occasion
Of filming in Bhutan.

NOV 2002
Scene112
TAKE 101

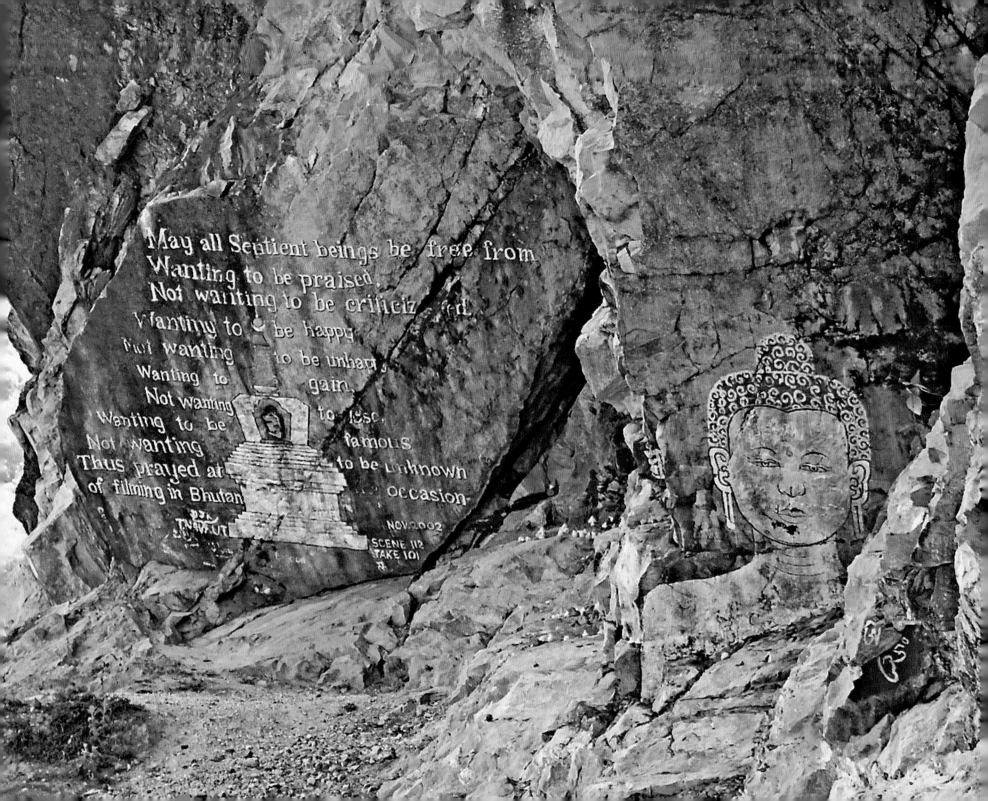

May all Sentient beings be free from
Wanting to be praised,
Not wanting to be criticized,
Wanting to be happy,
Not wanting to be unhappy,
Wanting to gain,
Not wanting to lose,
Wanting to be famous,
Not wanting to be unknown,
Thus prayed at occasion
of filming in Bhutan.

TNWFUT

NOV 2002

SCENE 112
TAKE 101

Prayer Flags, Bumthang

While a cluster of prayer flags like this is not an uncommon sight in Bhutan, each gathering fills a visitor with emotion. The tall pole in the center seems to be lifting the entire hill into the heavens.

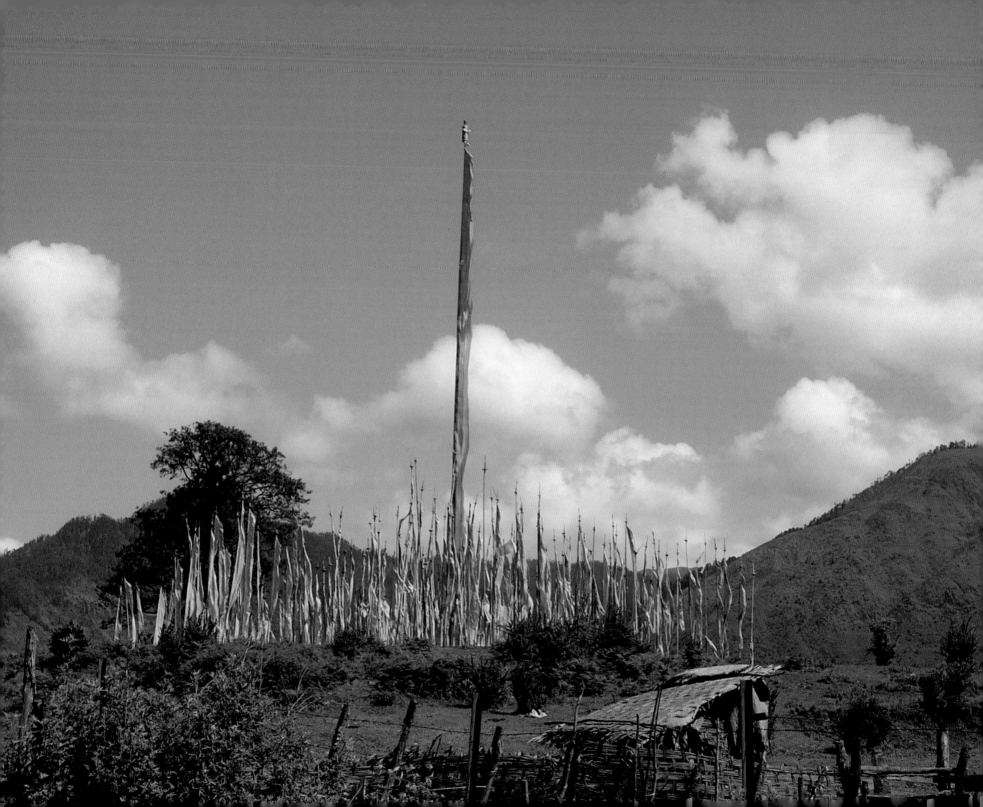

Puja, Bumthang

A family and their neighbors gather for a *puja.*

Pujas are ceremonies for the purpose of celebrating or honoring a person, a particular event, a spiritually significant date on the calendar, or an anniversary. *Puja* rituals can be performed communally, where friends, family or sangha gather for this purpose. Offerings are made; special words are spoken, sung and/or chanted; and often, a large meal is shared together. *Puja* can also be made privately, as part of one's daily Buddhist practice. In this case, the devotee would make offerings and pray alone. There would be no group activity.

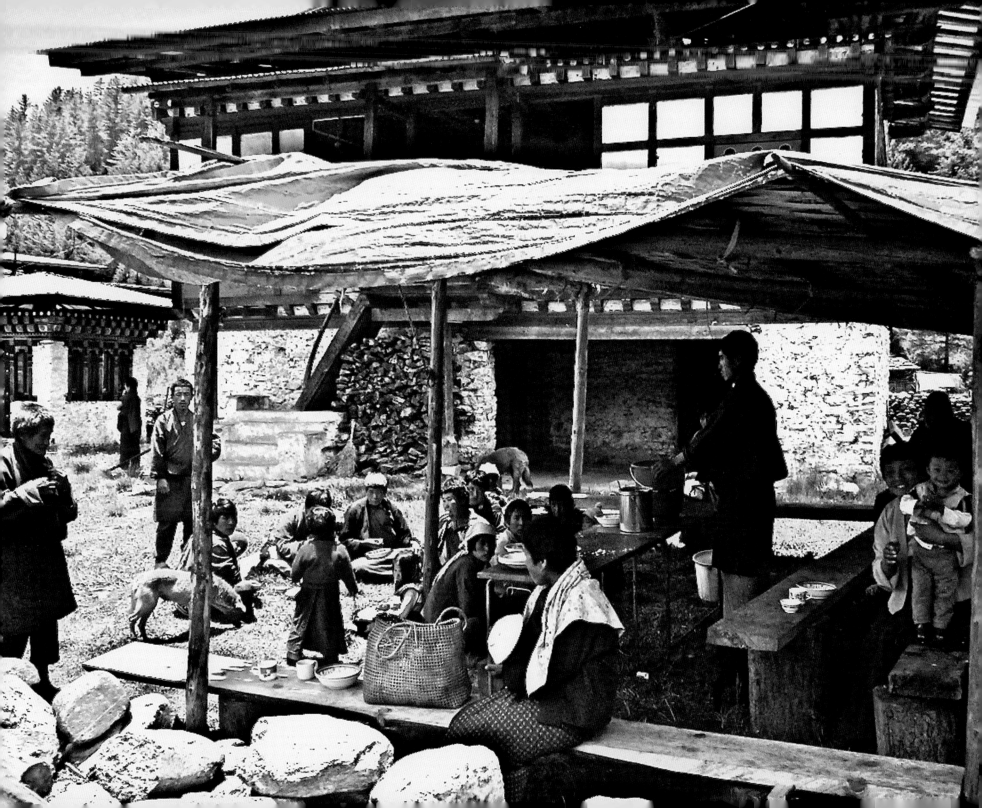

Tharpaling Goemba Grounds, Bumthang

Tharpaling Goemba was founded by Longchenpa, a celebrated 14th century monk.

Small shrines like this one are often found on or near monastery grounds. They can be built over running streams of water, which are engineered to turn prayer wheels inside the brick walls, spreading blessings into the air. There is a tiny opening in the front center where offerings are left and where you can see the prayer wheel turning.

The Secret Mantra is called "secret"
Not because it harbors any defect.
But rather it is hidden
From narrow minds upon the lower paths.

– Padmasambhava[11]

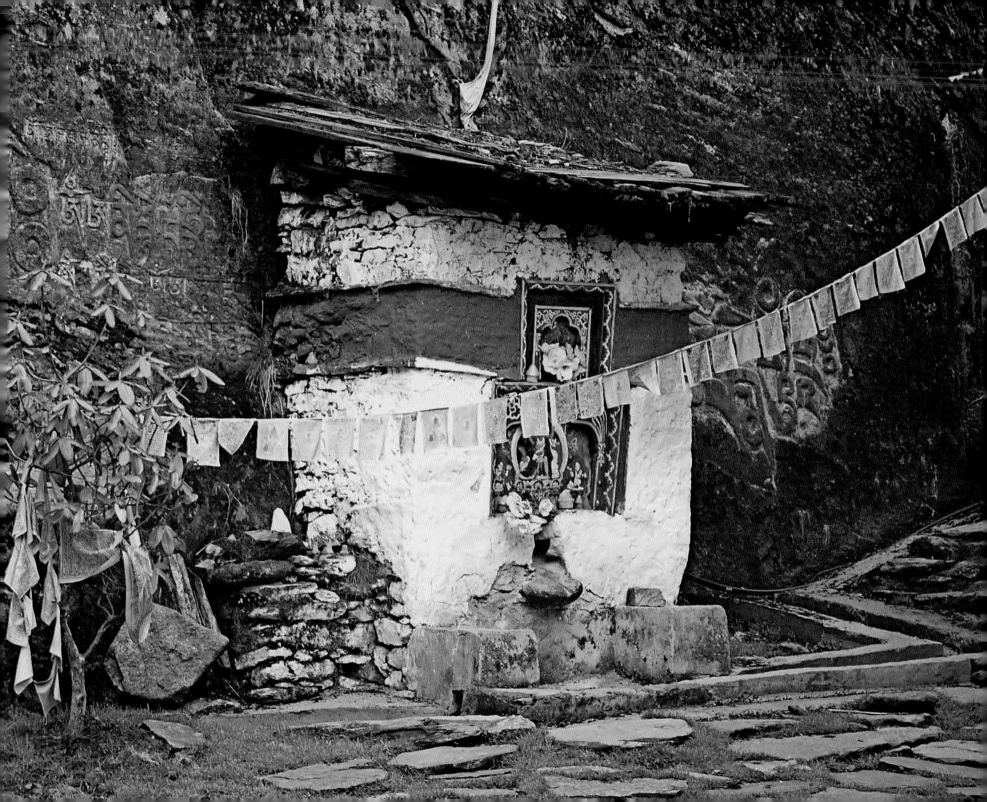

Tharpaling Temple Wall Carving

The Sanskrit letters for "om mani padme hum" (enlightenment is within all things) have been carved into a wall in the temple courtyard and painted.

Situated high in the mountains at close to 12,000 feet, this monastery feels quite remote and the air is thin and cool.

Inside one of the temples in the complex you will find two dark stones; one is about the size of a small volleyball and the other is like a small football. They are polished smooth from many years of devotional handling. The heavy, round stone has an imprint made by Yeshe Tsogyal. One can circumambulate the altar three times, holding this stone, to receive beneficial karma.

The smaller, football-shaped rock has a clear footprint, depressed about half an inch into the stone. It was made by Guru Rinpoche.

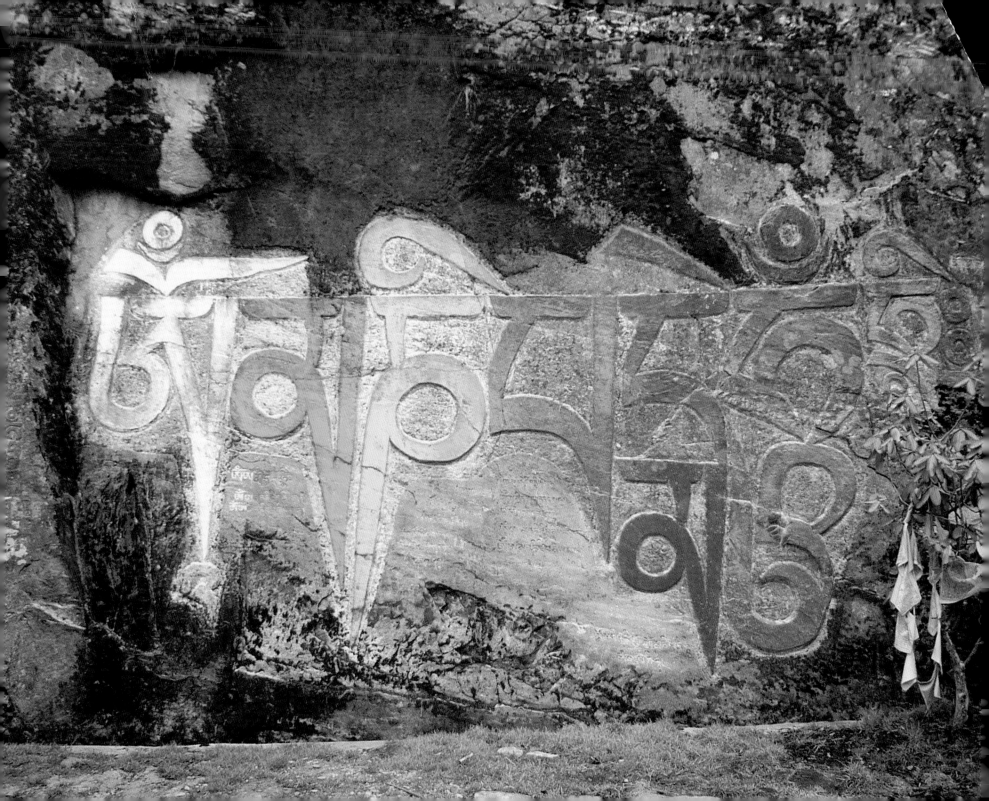

Tharpaling Goemba

At the top of the mountain temple complex a man spins a giant wheel, praying for the benefit of all sentient beings. He has been in this seat, spinning this wheel, for most of his life. He seems to be sealed into his perch the way objects placed in the nook of a tree will become, in time, wedged forever into the bark as it grows around them. When he smiles, there is more gum than tooth. You can imagine that his teeth were carried away over the years in the wind of the spinning wheel, in the whispered prayers on his breath.

His wife can be found, with short-cropped white hair and the maroon cloth attire of a nun, circumambulating the building most hours of every day. She, too, has been praying for us all, turning her small hand-held prayer wheel and chanting as she touches one bead after another on her mala. A bead and a step, round and round, a lesson in itself of the endless incarnations of unenlightened existence on the worldly planes.

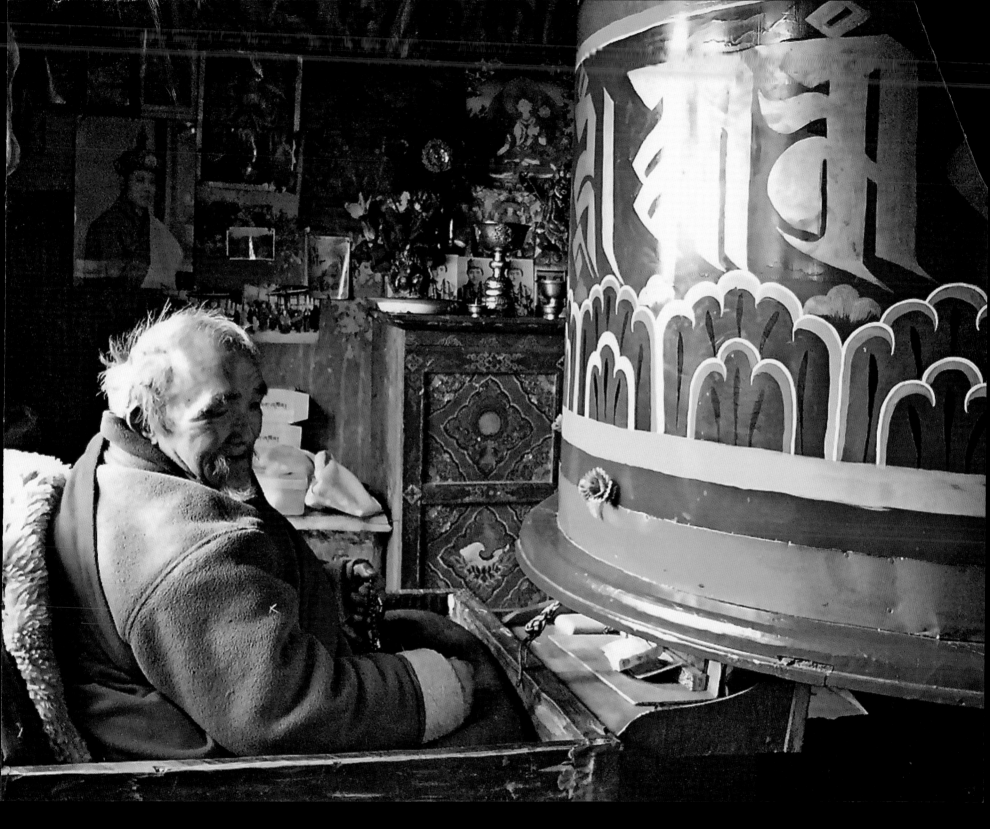

Wangdichholing Palace Grounds, Bumthang

Young monks run across the grass courtyard of the palace grounds like little ducklings after their mother.

This building was the first palace to be built in Bhutan and was the residence of the first, second and third kings. It is now inhabited by a small community of monks whom you can hear chanting and blowing *dungchen* (elongated horns) from the courtyard below the windows of their temple.

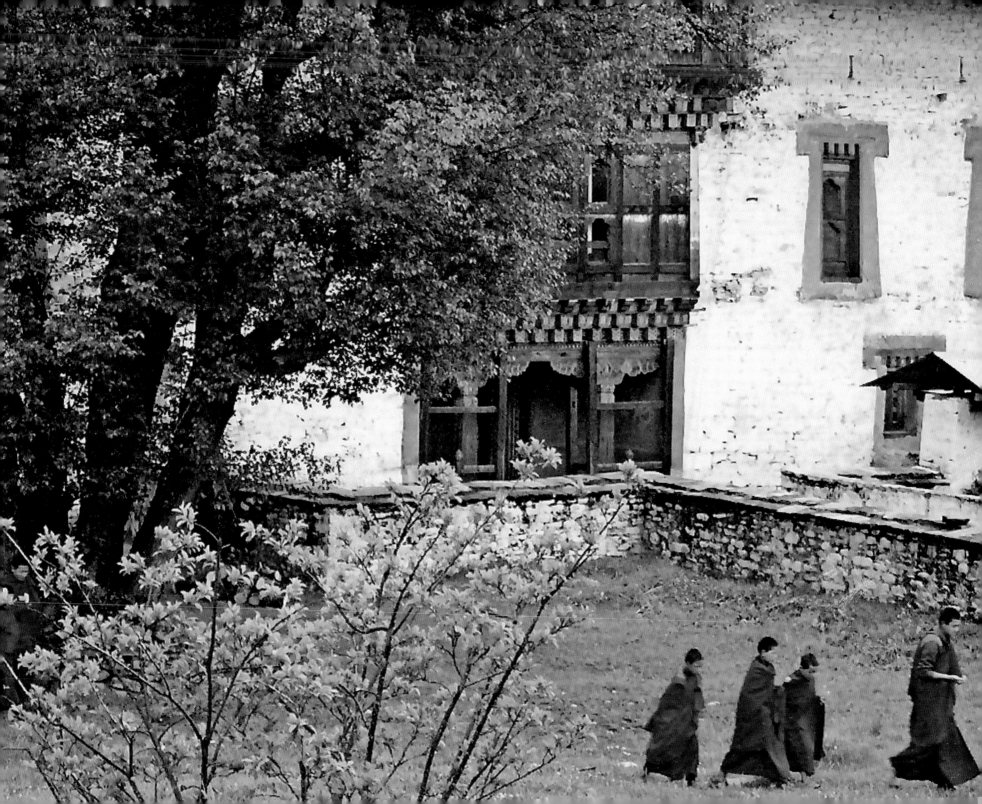

Membar Tsho (the Burning Lake), Bumthang

This lake was so named after a legendary event involving the *terton* Pema Lingpa, believed to be a reincarnation of Padmasambhava, which occurred in the late 15th century.

A *terton* (treasure revealer) is a title bestowed on someone who "discovers" spiritual teachings and shares them with others, either by speaking them or by writing them down. These teachings are called *termas* (treasures). *Termas* are essentially highly meaningful realizations that come to spiritually attuned beings. It is believed that these realizations are prepared, or "packaged," by great saints and are then left in other dimensions accessible only in certain empowered locations. Only another saint can perceive these sublime teachings and then, by speaking or writing them, allow them to be transmitted to a new generation.

Pema Lingpa was accused of faking his realizations by a local politician. He challenged Pema Lingpa to prove he was a real *terton* by diving into this lake with a lamp. He said that if the saint was authentic, he would return to the surface with the lamp still lit. If he were a fake, he would perish in the water. Pema Lingpa complied. He dove into the lake and stayed under the water long enough to prove his point, returning to the surface holding a statue and a box of treasures…with the lamp still aflame, of course.

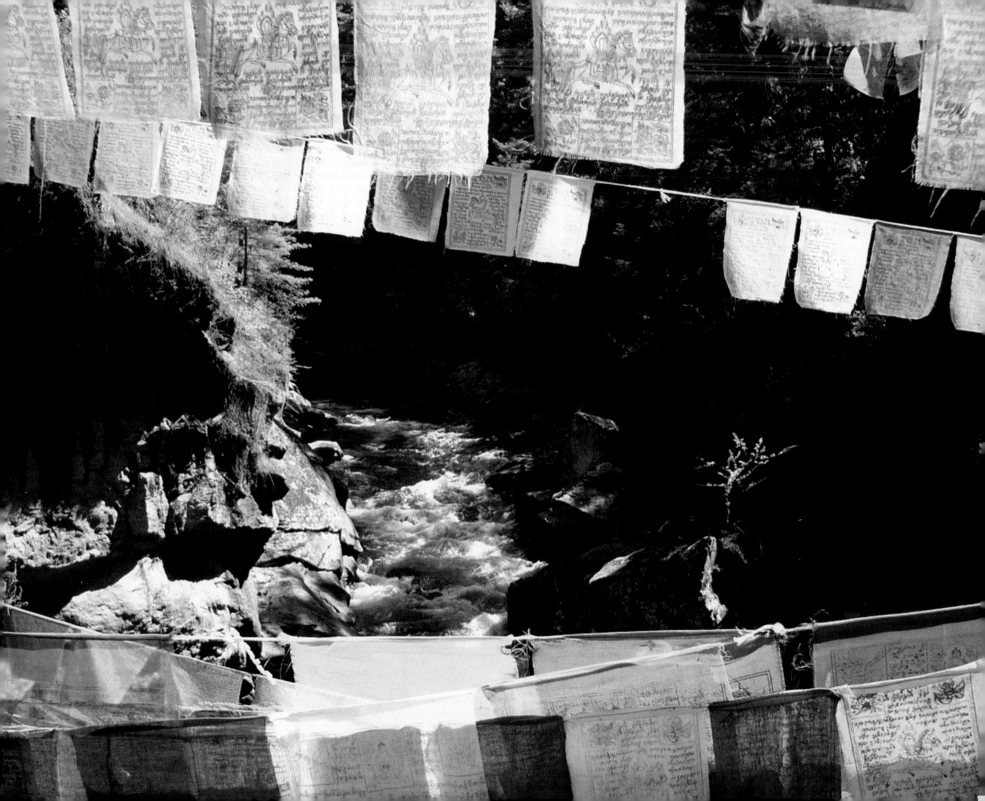

Membar Tsho Shrine

This altar is located inside a small shrine at the entrance to the Burning Lake area. Offerings are made under the gaze of these three guardians.

I am present in front of anyone who has faith in me, just as the moon casts its reflection, effortlessly, in any vessel filled with water.

– Padmasambhava

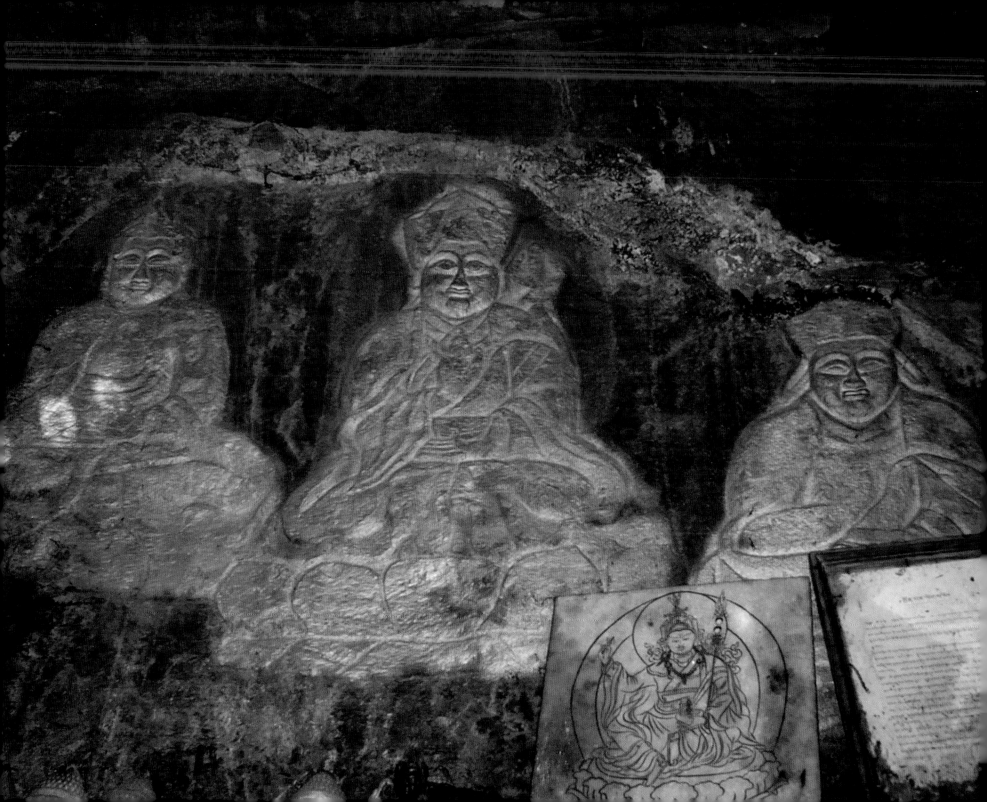

Membar Tsho

Visitors to the Burning Lake can come prepared with dough, butter, rope and small squares of wood. With these simple tools, you can construct your own butter lamps to offer to the lake. Whispering prayers, you then light the hand-made wicks pressed into the tiny cups of dough, and carefully set the little lamp adrift, watching the current carry your prayers into the distance.

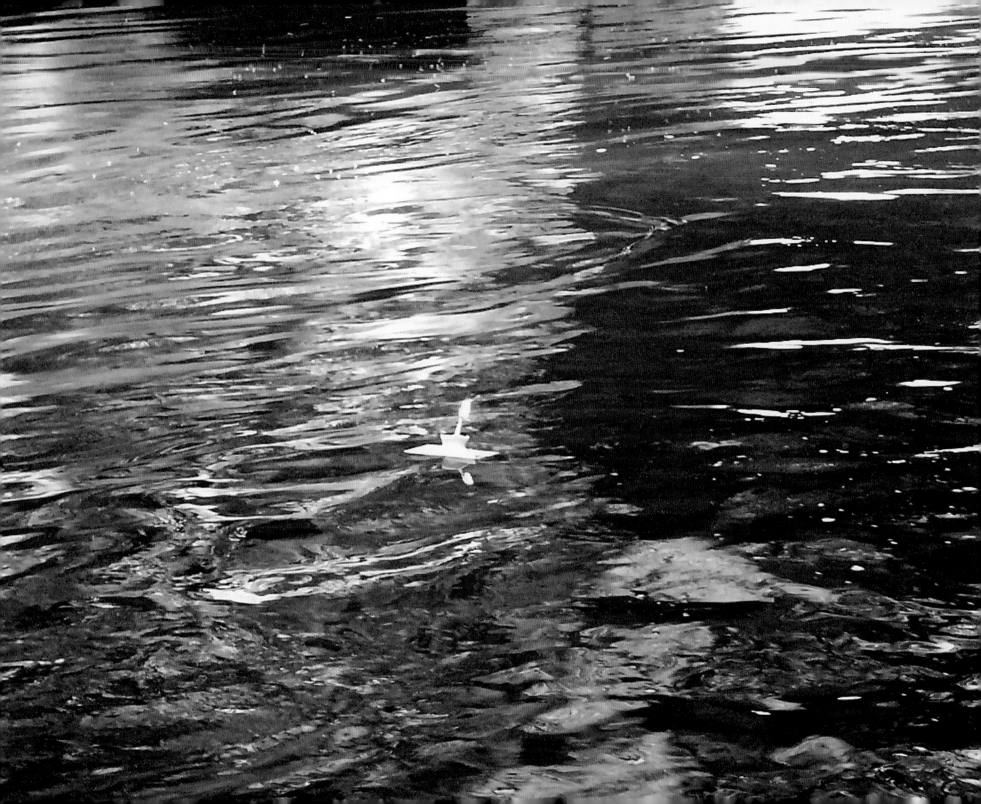

Tamshing Lhakhang Courtyard, Bumthang

Vajrapani looks out over a doorway in the courtyard of this revered temple founded in 1501 by Pema Lingpa.

The story of the temple is that Pema Lingpa constructed it with the help of three powerful *dakinis*. There is an enormous, gold statue of Guru Rinpoche in the center of the building, whose eyes are, atypically, looking directly up. Apparently, these *dakinis* could only work during the night. At first light, they had to leave abruptly, though the temple and statue were not yet finished. As they drifted up into the sky, the statue's eyes followed their hasty exit and have remained this way ever since.

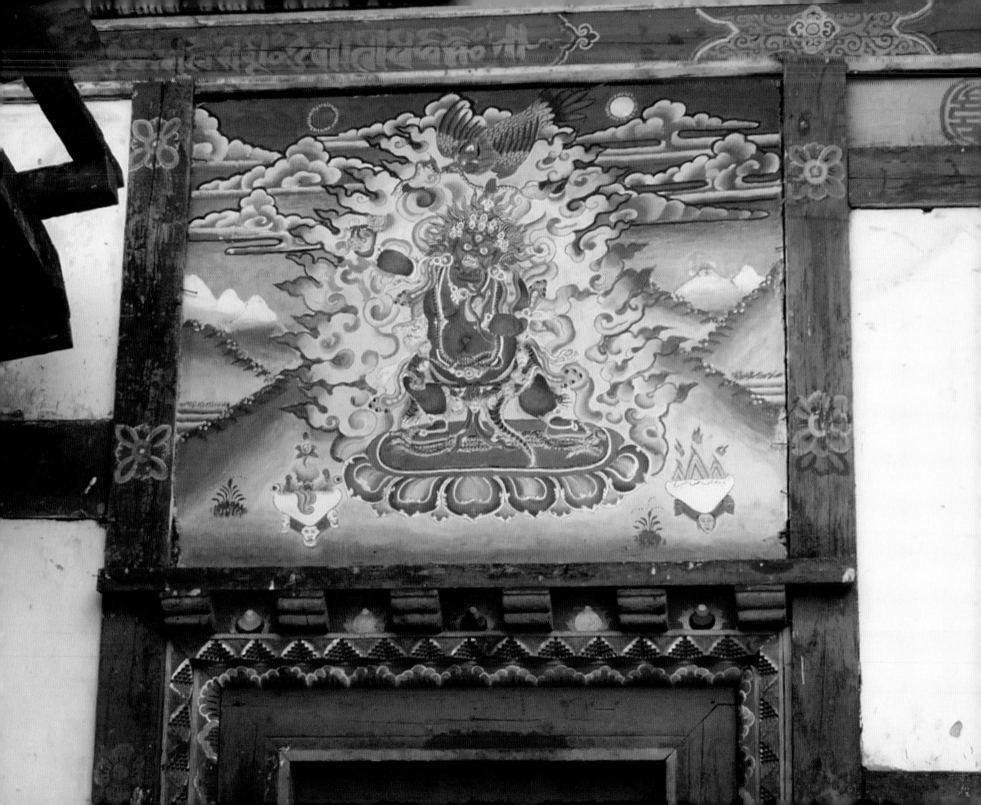

Tamshing Lhakhang Courtyard

These paintings, seen on the walls by the temple entrance, are over 500 years old. Religious artists traditionally use paints mixed from ground gems and other natural materials. It is believed this is why there is relatively little fading in the bright colors of even the oldest paintings.

Inside the temple, in a stone corridor that surrounds the innermost chamber, visitors can put on a shawl of chain mail made by Pema Lingpa himself. The shawl is fashioned from heavy, interlocking rings of metal and weighs over 50 pounds. It is believed that if you circumambulate the inner chamber three times bearing this burden on your shoulders, your sins will be released and you will win great merit.

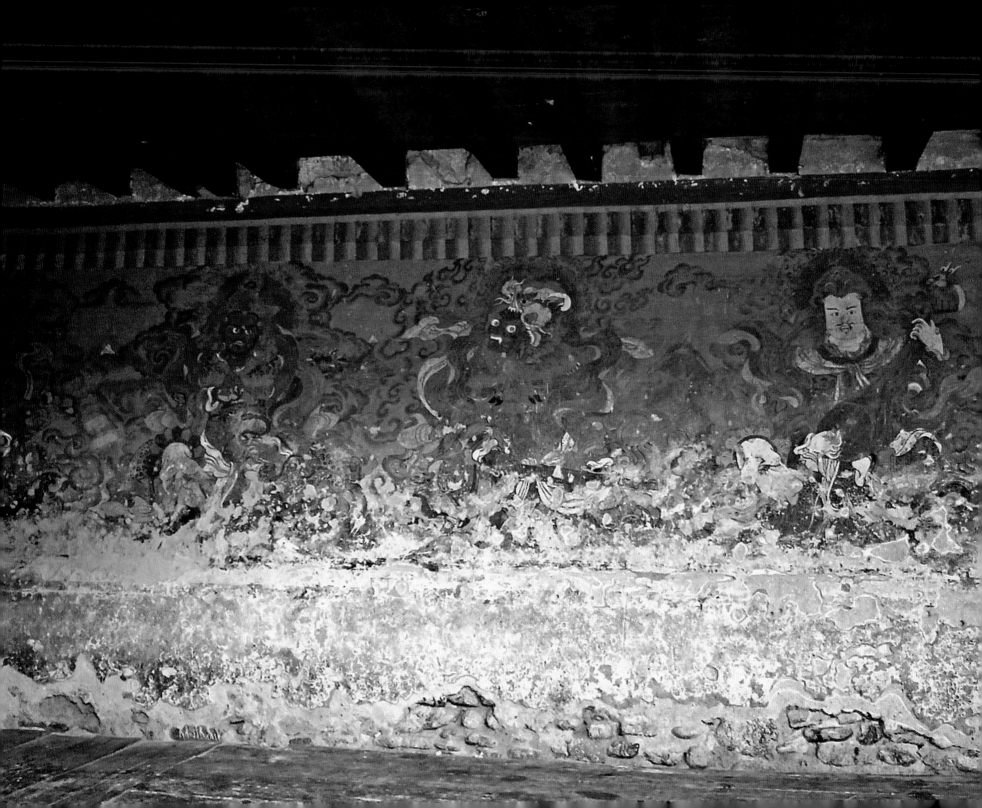

Young Monks, Bumthang

These young monks were spotted reclining in the sun outside a temple. There is almost nothing more evocative of Bhutan's cultural landscape than the sight of red-robed practitioners dotting the earth like spring flowers.

Better than a thousand hollow words
Is one word that brings peace…
Better than a hundred years of ignorance
Is one day spent in reflection…
Better to live one day
Wondering
How all things arise and pass away…
Better to live one moment
In the moment
Of the way beyond the way.

– Buddha[12]

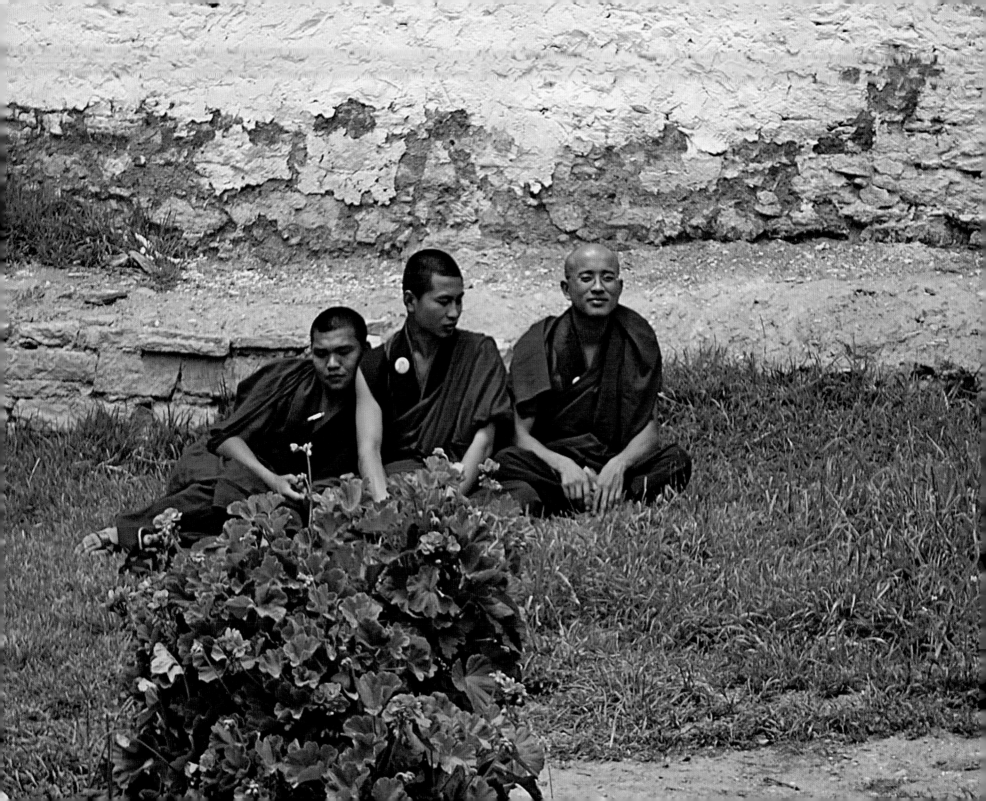

Kurjey Lhakhang, Bumthang

Kur Jey translates literally as "body imprint."

Guru Rinpoche came to this area at the desperate request of a king, Sendhu Raja, whose life force was being drained by a demonic local deity. Padmasambhava convinced the deity to stop his evil ways and become a protector of the *Dharma* (Buddhist teachings) instead. *Mahasiddhas* with spiritual powers as great as Padmasambhava's can be mightily persuasive! To "seal the deal" with this deity, Padmasambhava slammed his walking stick into the ground where this agreement was made. It is believed this stick eventually grew into the enormous Cyprus tree towering over the temple grounds.

Padmasambhava then meditated in a cave for three months in order to purify and heal the king. His meditations were so strong that his body actually left an indentation in the stone where he had been sitting. The Kurjey temple was built around this holy place. A palpable spiritual power continues to emanate from there.

The Kurjey complex now includes a third temple built by Her Majesty Ashi Kesang Choeden Wangchuck. The "Royal Grandmother," as she is known to locals, has built or restored temples across the country. Bhutanese see her as a living goddess. Temples with her influence certainly do have a lovely spiritual energy.

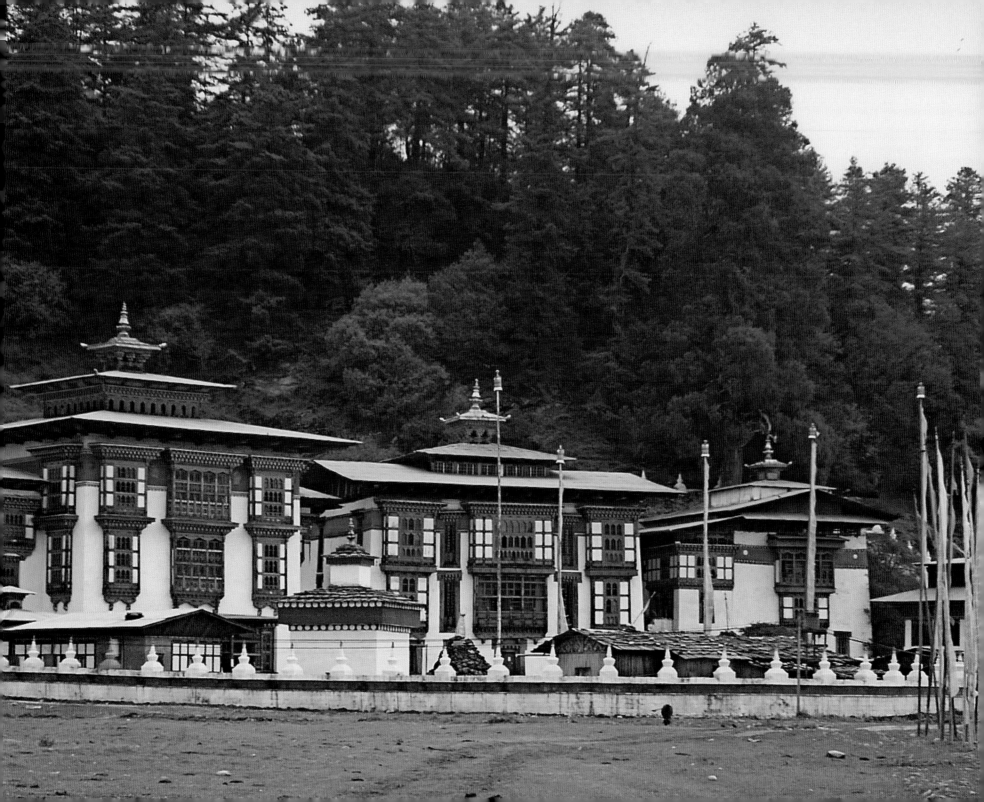

Kurjey Drupchu (Holy Water), Bumthang

As part of Guru Rinpoche's cure for Sendhu Raja's illness, he extracted medicinal water out of a rock above the current temple grounds. The water is still flowing from this rock. It is believed to have strong healing properties and many Bhutanese have personally witnessed its miraculous effects. Visitors can go right up to the spigot, cup some of the flowing water in their hands, toss it three times into the land as an offering, and then drink it or even bathe in it.

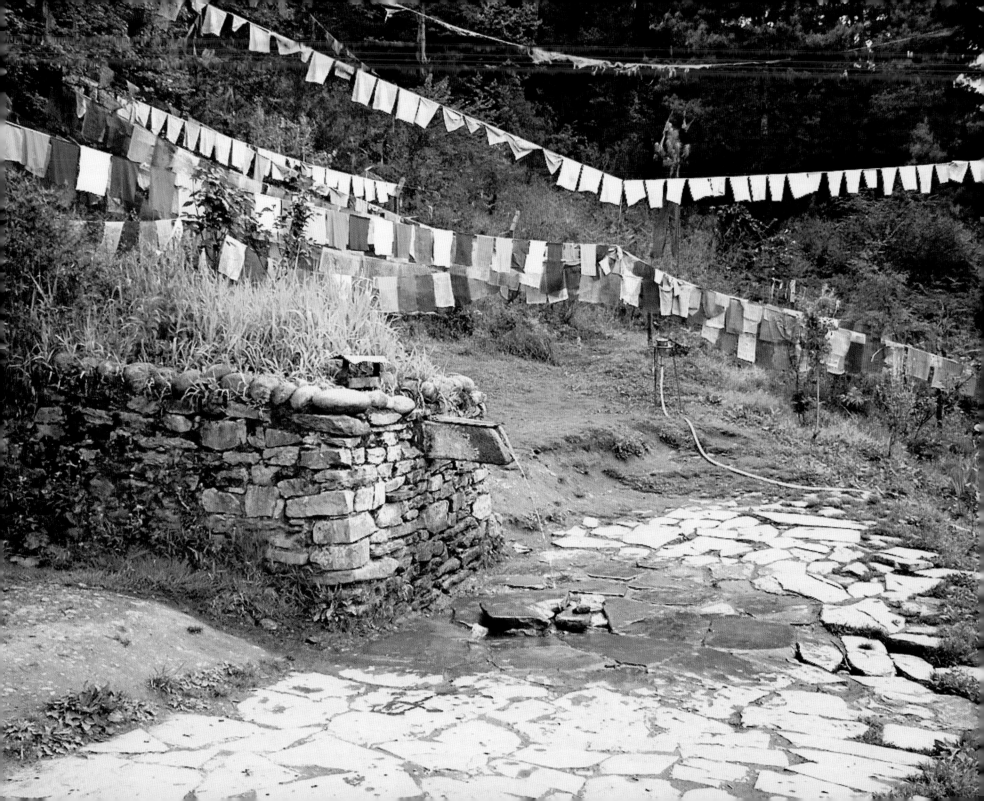

Vajrapani Painting, Kurjey, Bumthang

On a hill near the entrance to Kurjey, observant visitors will find this extraordinary image of Vajrapani, painted on a large, uneven rockface. Unlike the images created for the movie, "Travelers and Magicians," this painting is very, very old.

> This rock of your body believing in an I
> Must be ground to powder, Naropa.
> Look into the mirror of your mind, the radiant light.
> The mysterious home of the Dakini.
>
> – Tilopa[13]

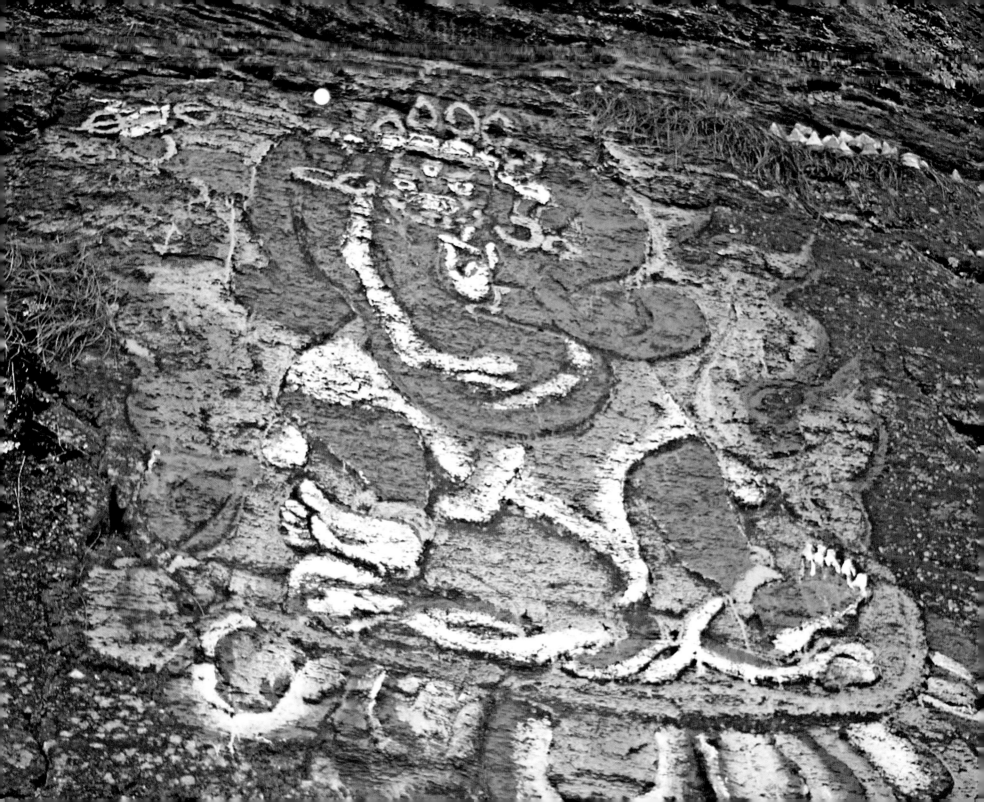

Chorten Nyingpo Lhakhang, Chhume, Bumthang

Here we are treated to a rare image of the interior of Yab Tenpey Nyima's historic temple.

During a special celebration open to outsiders, monks chant and blow the ornate *dungchen* for hours. This is one of the only temples and occasions where photographs were permitted to be taken by visitors.

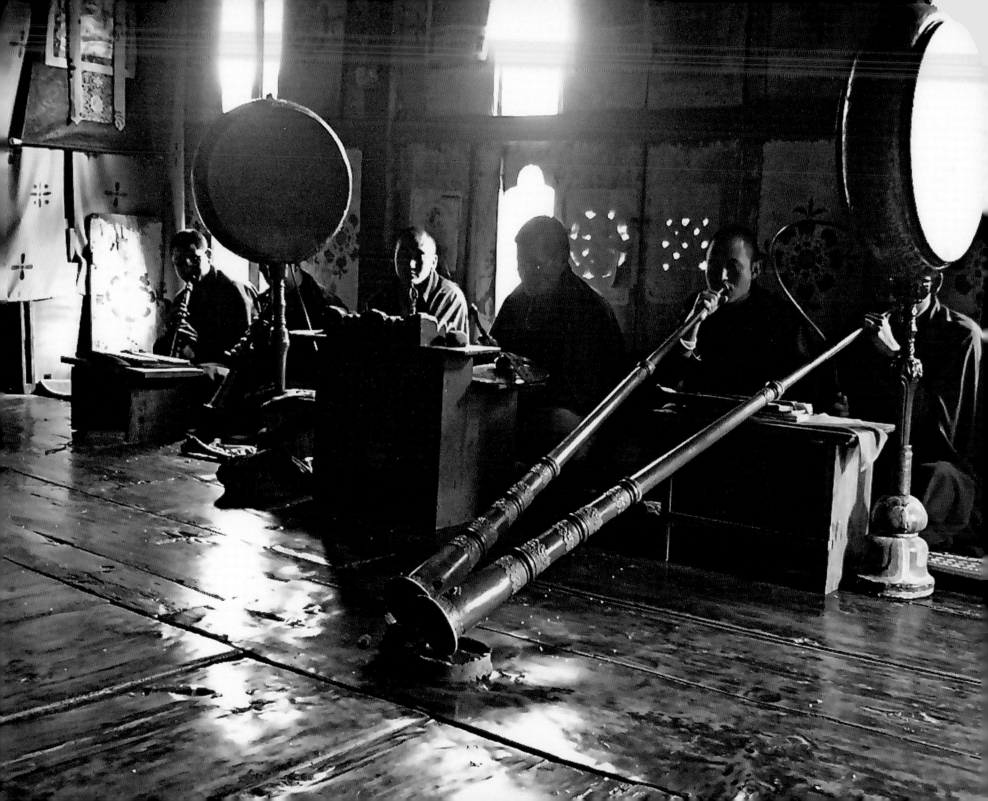

Chorten Nyingpo Lhakhang Grounds

With a light mist falling, guests of the ceremony alighted from the temple and found a charming pastoral setting outside.

One can imagine the quiet contemplation this peaceful environment must afford the resident monks.

Mount Jomolhari

Bhutan's second highest mountain can be seen on the left, measuring 23,996 feet.

It is considered sacred simply being fortunate enough to see this extraordinary white-capped peak, which is often hiding behind a mask of clouds.

We'll find our way out when the mist
clears.

– Brigadoon[14]

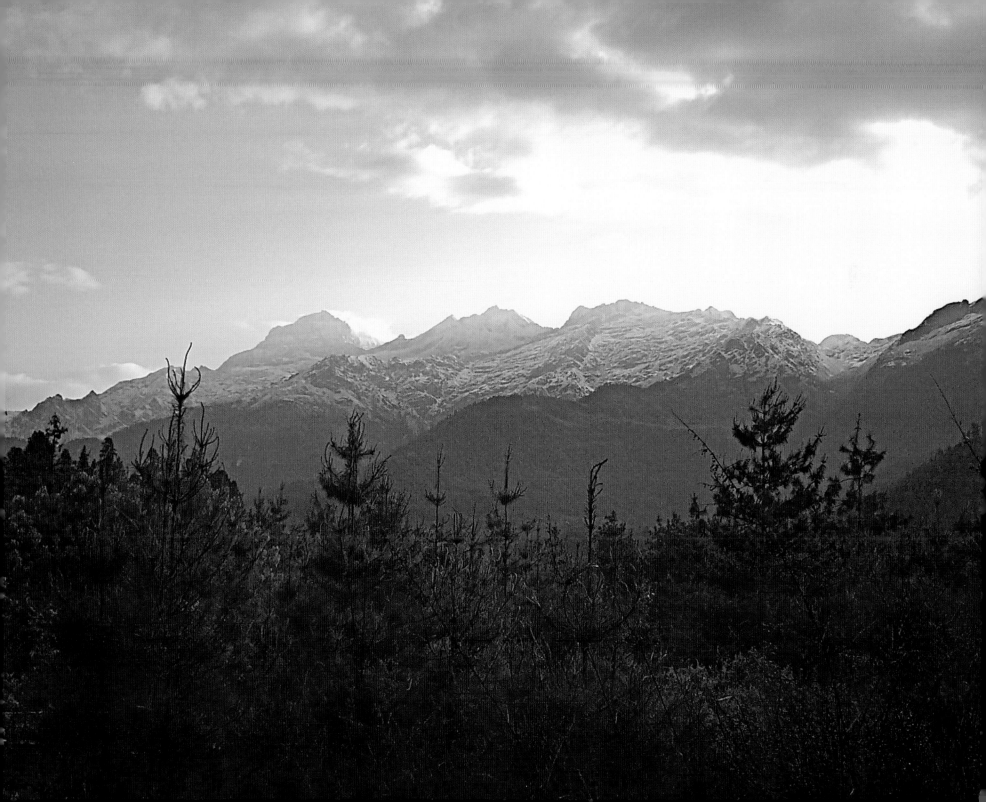

Glossary

Kuzuzangpo-la:	Greetings ("la" is an added term of respect)
Dzong:	Fortress
Lhakhang:	Temple
Goemba:	Monastery
Chorten:	Stupa
Chhu:	River
Kur:	Body
Jey:	Imprint
Chholing:	Palace
Dungchen:	Elongated temple horns used in monasteries
Mahasiddha:	A person who has attained a profound level of enlightenment, and is also capable of extraordinary feats of healing and the transmission of spiritual energy, among other powers – though he or she may not necessarily ever publicly use or display these skills.
Terma:	Spiritual "treasure"
Terton:	A person who recognizes *termas* and then shares them with others.
Puja:	A form of ritual worship.
Dharma:	The essence of spiritual knowledge, the Truth. One of Buddha's Three Jewels, which are the Buddha (teacher), the Dharma (teachings), and the Sangha (a community of those who hear the teachings).

Endnotes

1 Lost Horizon. Dir. Frank Capra. Perfs. Ronald Coleman, Jane Wyatt. DVD. Sony Pictures, 1937.

2 Thomas Byrom, *Dhammapada: The Sayings of the Buddha.* (Boston: Shambhala Publications, Inc., 1976), p. 75.

3 Byrom, p. 25.

4 Guru Rinpoche (according to Karma-Lingpa), *The Tibetan Book of the Dead: The Great Liberation Through Hearing in the Bardo (the Bardo Thödol),* trans. Francesca Fremantle and Chögyam Trungpa. (Boston:Shambhala Publications, Inc.), p. 87.

5 Dilgo Khyentse Rinpoche, *The Heart of Compassion: Instructions on Ngulchu Thogme's Thirty-Sevenfold Practice of a Bodhisattva,* trans. Padmakara Translation Group. (New Delhi: Shechen Publications, 2006), p. 130.

6 Keith Dowman, *The Divine Madman: The Sublime Life and Songs of Drukpa Kunley,* trans. Keith Dowman and Sonam Paljor. (Varanasi: Pilgrims Publishing), p. 63.

7 Ibid, p. 94.

8 Gyalwa Changchub and Namkhai Nyingpo, *Lady of the Lotus-Born: The Life and Enlightenment of Yeshe Tsogyal,* trans. Padmakara Translation Group. (Boston: Shambhala Publications, Inc., 1999), p. 177.

9 Byrom, p. 18.

10 James Hilton, *Lost Horizon.* (New York: Pocket Books, 1933), p. 40.

11 Gyalwa Changchub and Namkhai Nyingpo, p. 21.

12 Byrom, p. 18.

13 Herbert V. Guenther, *The Life and Teaching of Naropa.* (Boston: Shambhala Publications, Inc., 1963), p. 69.

14 Brigadoon. Dir. Vincent Minelli. Perfs. Gene Kelly, Van Johnson. DVD. Warner Home Video, 1954.

Appreciation

In 2009 I was extremely fortunate to make my first visit to the enchanted Kingdom of Bhutan. While many tourists have had the joy of traveling through this land, I was particularly blessed to have as my guide the incomparable Lt. Colonel Kado, also known as "Dasho." The title, *Dasho*, is an honorific term that translates similarly to the British word "Sir." Dasho earned his title through 22 years as Aide de Camp to the beloved fourth King, and ten years as Aide de Camp to four queens and the royal children.

Dasho's status (and his many friends) enabled me to enter temples, sanctuaries and locales that most visitors could never gain access to, even if they managed to find these hidden jewels. Through his hospitality and generosity I was introduced to members of the royal family, government officials, beloved rinpoches, monks and abbots.

I had the immense good fortune to meet Her Majesty the Royal Grandmother, Ashi Kesang Choeden Wangchuck, a rare and special appearance. She took my hands and smiled and in her eyes I saw the entire population of Bhutan – all of whom are, to her, like her very own "adopted" children.

One of my happiest moments in Bhutan was the blessing of sitting for a short time with His Holiness the Je Khenpo. He invited me to meet with him despite not feeling well at the time, because he heard that one of this American visitor's great wishes, in traveling to the other side of the world, was to see him in person. What can one say about such a special encounter? I am very lucky. He is a living treasure.

I was honored to be so warmly welcomed into the royal palace in Thimphu by Her Highness Ashi Kesang Wangmo Wangchuck, a beautiful storybook princess. Her Royal Highness devotes her time and energy to helping the poorest and most desperate citizens. There, I was introduced to her family's spiritual advisor, the jovial Datong Tulku Rinpoche, the successor to his teacher, the great Dilgo Khyentse Rinpoche. Datong Tulku Rinpoche allowed me to enter his historic monastery and bear witness to its untouched spiritual riches prior to a major renovation.

I am very grateful to every individual whom I met in Bhutan, the celebrated and the unknown. Each encounter has enriched my life. I hope this modest book can convey some of the color, kindness and *joie de vivre* that I was so privileged to experience during my journey through the Land of the Thunder Dragon.